CONTENTS

D1387399

DIRECTOR'S FOREWORD

Choosing between outstanding photographic portraits is a delightful but demanding process. With so many subjects captured by so many different photographers from sixty countries, the judging process gives the illusion of the world marshalled for close examination through a judging room in London. The 2014 submission included an astonishing range of pictorial skills deployed across every style and genre, and it is sometimes hard to pin down what it is that makes the best portraits stand out. Is it the focused expression? The complex composition? Effective lighting, whether with colour or black-and-white prints? The scale of the final image, whether large or small? Or simply an empathy with the subject?

Whatever the narrative or scenario, the selected portraits clearly express many aspects of pride and human integrity, mixed frequently with admiration or affection, and, occasionally, with love. As viewers, we engage with great portraits because they offer insights into particular individuals, groups or families, and, crucially, into the creative engagement between photographer and chosen subject. We know we were not there, but in the best portraits we are allowed to believe that we might have been nearby.

Many congratulations go to this year's winners: David Titlow, Jessica Fulford-Dobson, Birgit Püve and Blerim Racaj. And I am, as always, very grateful to the many photographers who submitted 4,193 images to this year's *Taylor Wessing Photographic Portrait Prize*. I am keen to thank Simon Crocker, Chairman of the John Kobal Foundation, and Terence Pepper, Trustee of the Foundation, for their special support through which a younger photographer is awarded the 2014 John Kobal New Work Award and a commission to make a new portrait in the world of the film industry. My thanks this year also go to the David Ross Foundation for its support by which six students were able to follow the process of the 2014 Prize.

I should like to thank my fellow judges: Robin Muir, Phillip Prodger, Niri Shan and Bettina von Zwehl. In considering all the many excellent images entered, they were thoughtful and determined, and had very good debates in order to come to their final choices. My thanks also go to National Portrait Gallery staff, designers Thomas Manss & Company, photographer Eamonn McCabe and interviewer Richard McClure for all their hard work on the exhibition and catalogue. I am grateful to the White Wall Company for their excellent logistical work.

The National Portrait Gallery is delighted to continue its productive partnership with Taylor Wessing, and my sincere thanks go both to the company and to Tim Eyles, UK Managing Partner. Taylor Wessing's support not only makes it possible to create this important international exhibition each year, but also enables vital community, educational and outreach work.

SANDY NAIRNE
DIRECTOR, NATIONAL PORTRAIT GALLERY

SPONSOR'S FOREWORD

The *Taylor Wessing Photographic Portrait Prize* marks an exciting time of year for Taylor Wessing. We place great importance on supporting creativity, and by participating in this fascinating artistic venture we closely connect our firm's culture and values to our ongoing support of the arts. In our seventh year of sponsoring the *Photographic Portrait Prize* we continue to be inspired by what we see.

Through the sixty photographs chosen from the thousands of entries submitted for the exhibition this year, we are afforded an intimate look at the lives of individuals from around the world. The family is a subject that features more frequently this year than previously, with familiar family scenes captured beautifully in a variety of styles, not least in David Titlow's exquisite winning entry, reminiscent of the Dutch Masters. Canine relationships also seem to feature more prominently. Perhaps we can surmise that companionship – or a lack of it in some of the more heart-wrenching images – is the overarching theme.

Subjected to an intensive judging process in which they were viewed again and again alongside thousands of others, the chosen photographs continued to intrigue, their nuances evoking a subtly different response with each viewing. Art and artists have a significant place in our culture and society, but institutions such as the National Portrait Gallery hold an even more important status beyond their extensive collections. They are centres of study and research, places of learning and outreach; they bring history to life while addressing current questions and debates. Although the National Portrait Gallery was founded in 1856 to promote British history and culture, the Collection and the Gallery now go far beyond that aspiration in reflecting the diverse and multicultural world we live in today. Time and time again the images submitted and selected for the *Taylor Wessing Photographic Portrait Prize* reflect this diversity of culture, demonstrating the borderless nature of portrait photography and of the National Portrait Gallery, which has far exceeded its original founding principles.

Part of the beauty of the Gallery is that it is accessible to everyone. In today's frenetic world, we hope that many will pause to enjoy and consider these images and the thoughts they provoke. We thank the National Portrait Gallery for the pleasure of our ongoing relationship, and the photographers whose artistry has once again made us pause and reflect.

TIM EYLES
MANAGING PARTNER, TAYLOR WESSING LLP

ON BEAUTY
EAMONN MCCABE

Taking a portrait of somebody is a very intimate process. Taking a portrait of somebody you have never met before can also be very intimidating. Add to this the setting of an unfamiliar hotel room and a nervy PR person on hand adding, 'You have just ten minutes. Oh, and, by the way, he hates having his picture taken,' and your anxiety swells further. This is combined with the technical challenge of lighting and the constant thought running through your head: Will your camera actually fire when you see that 'moment' everybody talks about? Is it any wonder so many of us take to landscape photography in the end?

In my career I have been lucky enough to photograph the beautiful French actress Juliette Binoche twice — once in the above-mentioned nondescript hotel room (opposite) and once at the Almeida Theatre in Islington, north London (right). I was looking forward to meeting her during a break in rehearsals at the Almeida. Having reconnoitred the theatre the previous day and found lots of nooks and crannies in its various corridors, I set up my tripod near a good corner with a great background — the most important thing in any photograph (except for the sitter, of course). Then we met — aforementioned PR person in tow — the usual niceties were exchanged, and then the bombshell was dropped: 'You can photograph me ... but only while I am having lunch in the restaurant, nothing else.' Now Juliette is a gorgeous woman, but a photograph of her with a forkful of salad would do little for her image or my reputation as a portrait photographer. I was there for twenty minutes trying to dodge the fork as it travelled from plate to mouth. I got one or two reasonable shots without the cutlery, but none that I would call a portrait. It later emerged that she had promised the photographer from the *Telegraph* my corner.

The next time I photographed Juliette was at a top London hotel. I was shown into the room. She sat there, looking stunning in a tweed coat. The sunlight was pouring in, so no need for any lights — one less thing to go wrong. Brilliant. Last time I could not get a word out of her, so I was nervous, but I need not have worried. I noticed she was wearing a great pair of Camper shoes, which were very popular at the time. I said, 'I love your shoes,' and she revealed she had just bought them and loved them too. We were away. I had found a way in. The next ten minutes produced some of the best portraits I had taken for some time.

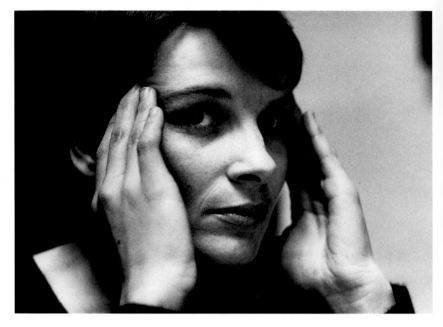

JULIETTE BINOCHE
FEBRUARY 1998

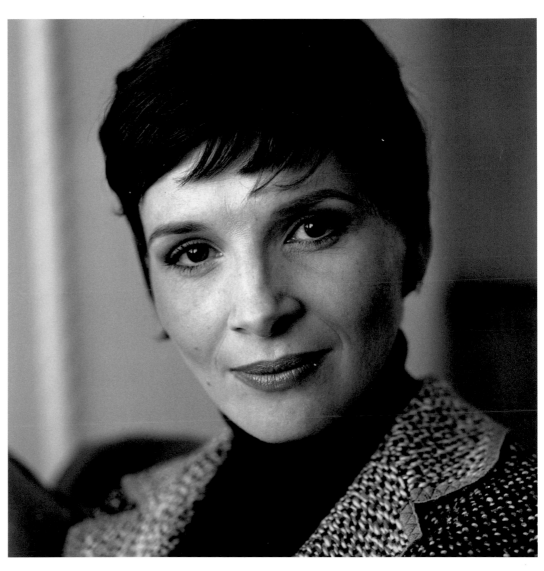

JULIETTE BINOCHE
JULY 2006

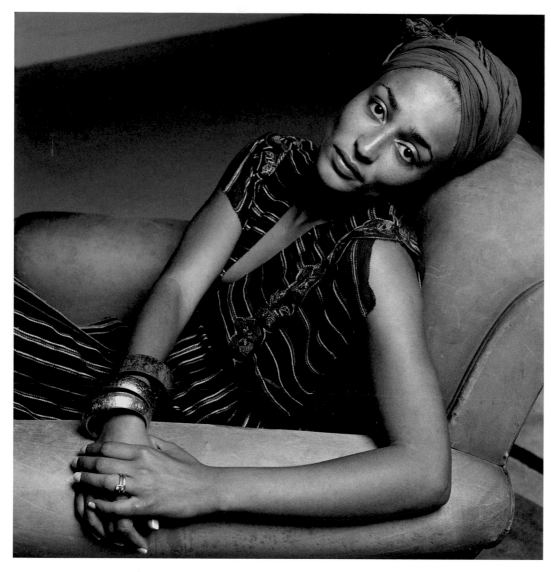

ZADIE SMITH
AUGUST 2005

Over the years I have been fortunate in having the opportunity to photograph some of the most beautiful women in the world: Binoche, Charlotte Rampling, Jane Russell and Juliet Stevenson. But I was once asked if I had ever really captured beauty itself. It was for a debate at Hampton Court Palace. I knew their art historians would roll out the classic painted portraits from their vaults, and I was racking my brain to see if I had anything that could really be classified as *beauty*. It is one thing to take a photograph of a beautiful woman but to capture beauty is quite another. I decided to show ten photographs in this illustrious company and try to argue my case and take on the historical daubers. I showed Binoche and the others, but realised that while they were photographs of beautiful women, only one really captured *beauty* as a concept: a photograph of Zadie Smith the writer (opposite).

The session with Zadie did not start well. I met her at her publishers, Penguin, on the Strand in London. I was shown into an empty boardroom and my heart sank. There was nothing I could use as a background, not even a window. The only chance I had was to ask her to sit on the old, worn tan leather chair that was fortunately in the room. When Zadie arrived she was very nervous and quiet, and had been smoking roll-ups on the balcony – which would have been great for the photographs, but not for her image. The book she was promoting was *On Beauty*, a novel about a mixed-race British–American family living in America. She looked stunning, and the first thing I spotted was her lovely turban in the same colour as the wonderful chair. There was hope. I shot from above to get rid of the boring walls in the background and she looked great, if a little nervous. I had my ten minutes and was reasonably happy, but I had not got anything really special. During these ten minutes you have to get on with a total stranger and ask them to become intimate with you, as you take something so personal as a portrait. Portrait photographers have a saying: 'the sitter gives you something'. Some photographers, including Steve Pyke of *The New Yorker* – a great friend of mine – call it an 'exchange'. It happens when you see something in the viewfinder and your heart skips a beat as you realise that you have got something special. My 'exchange' with Zadie came at the end of our session, when I asked her to lean back in the chair. She could only say no, I thought, and I already had some good stuff. But she entertained my request and all of a sudden the mood became intimate. It was as though we could be friends, not just a photographer and a writer. I felt I had photographed real beauty, not just a beautiful woman.

In 2005 I had the privilege of being on the judging panel for the *Taylor Wessing Photographic Portrait Prize*. All entries are judged anonymously and I was determined not to select the 'typical' Taylor Wessing photograph. I used to describe (I now realise unfairly) the kind of portrait that won as 'a bored-looking East European woman in a wood, shot on 10 x 8 film for the extra quality. Oh, and by the way, freckles really help.' The year I judged we had around 6,000 entries and after a short period of time into the judging process, as was expected, we were surrounded by a lot of photographs of very thin, young blonde women standing in woods. I realised then that it was the quality of the photograph, as well as the content, that was getting this type of photograph through. Even I, having initially set out to exclude them, found myself in their favour. I had entered the competition a couple of times over the years but never featured in the exhibition, let alone got anywhere near winning. I then set about trying to get something into the most prestigious photography exhibition in London.

When I took the photograph of the artist Sarah Lucas (opposite), I had a gut feeling it was special. I had been sent by the *Guardian* to take some pictures to promote the launch of *Snap*, part of the Aldeburgh Festival at Snape, not far from my studio in Suffolk. In 2011, *Snap* featured works inspired by Benjamin Britten, co-founder of the Festival. I found Sarah's house, where Britten once lived, down a tiny lane in the heart of the county. It had a huge children's swimming pool and the day was beautiful and sunny; I could see picture possibilities everywhere. After taking some photographs of Sarah in her studio with her new work, I had to try to get something by the pool – the rich blue colour of the water was enticing. It was very bright and she had sunglasses on, which tends to neutralise a face, and I asked her if she could bear a few shots without them. She duly obliged. The wind blew her hair across her face and I got that feeling again, this time maybe not capturing beauty as such, but an earthly reality instead. She had really given me something, an honesty. She did not mind how she looked and I loved that. In 2012 I entered the photograph into the competition and am thrilled to say it appeared in that year's show. I was a little worried about what Sarah might think, as the image is so raw. But then I thought she is an artist – that is what life is like, but not many people are brave enough to show us that truth. When I met her a few months after the exhibition, she gave me a hug and invited me to a party for that year's *Snap* festival, so it is safe say that she held no grudge!

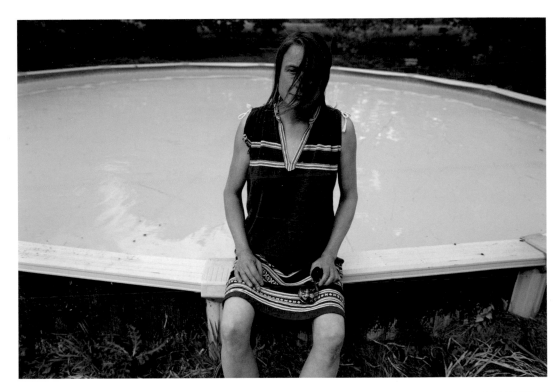

SARAH LUCAS IN SUFFOLK
MAY 2011

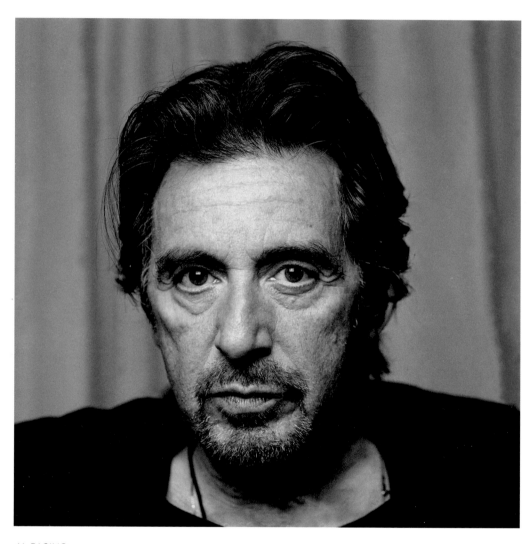

AL PACINO
DECEMBER 2004

Men can also be beautiful. Some, such as Jude Law, have beauty when just standing still. Others, such as Michael Gambon and John Hurt, have a more rugged and craggy beauty. With men there tends to be less preparation time for hair and make-up than with women, but I do not really have a preference: it is the face that I really enjoy. I once photographed Al Pacino in the now-familiar bland hotel room, where he looked more famous than he does on screen (opposite). He asked, 'what do you want to do?' I said I really loved close-ups and he humoured me by saying he loved them too. Before we started I noticed he had some remnants of his morning coffee on his lips and pointed it out to the great man. He replied: 'F**k it. Who cares? Let's have some fun.'

Taking a portrait of another photographer can be very intimidating, as you think your sitter knows more about it than you do and that they are watching your every move (which I am sure they are not). I have photographed many famous photographers including Annie Leibovitz and Richard Avedon, but undoubtedly my worst experience was photographing my hero David Bailey in his own studio. I did not take any lights, as I knew his studio would be full of daylight. I set up my tripod, attached my ancient Hasselblad and tried to imagine I was in charge in this wonderful setting. But Bailey likes to be boss in his own space and after a few minutes wanted to know what I was seeing through the lens. He became the photographer and I became the sitter. An honour indeed, I mistakenly thought. He crouched over my ancient equipment and looked through the viewfinder and swore like a trooper, 'Bleedin' hell, it's like an ashtray in here. If you were one of my assistants I would fire you!' Try taking a portrait after that.

EAMONN MCCABE is one of the UK's leading photographers and four-times winner of Sports Photographer of the Year. In 1985, McCabe was named News Photographer of the Year for his work at the Heysel Stadium disaster and he is Fellow of the Royal Photographic Society and the National Media Museum. His books include *The Making of Great Photographs* (2005), *Eamonn McCabe: Sports Photographer* (1982) and *Decade* (2010).

THE PRIZES

TAYLOR WESSING PHOTOGRAPHIC PORTRAIT PRIZE

The *Taylor Wessing Photographic Portrait Prize* is open to photographers from around the world aged eighteen or over.

The first prize winner is David Titlow, who receives £12,000.

The second prize winner is Jessica Fulford-Dobson, who receives £3,000.

The third prize winner is Birgit Püve, who receives £2,000.

The fourth prize winner is Blerim Racaj, who receives £1,000.

THE JOHN KOBAL NEW WORK AWARD

The John Kobal New Work Award is awarded to a photographer under the age of thirty selected for the exhibition. The winning photographer receives a cash prize of £4,000 to include undertaking a commission from the Gallery to photograph a sitter connected with the UK film industry.

The winner is Laura Pannack.

If you would like to join the mailing list to receive an entry form for next year's *Photographic Portrait Prize*, please register your interest online at: www.npg.org.uk/photoprize or send your full contact details to:

Photographic Portrait Prize 2014
Marketing Department
National Portrait Gallery
St Martin's Place
London WC2H 0HE

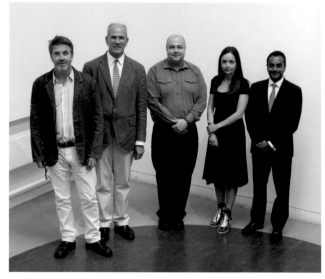

PHOTOGRAPH BY CLARE FREESTONE, 5 AUGUST 2014

THE JUDGES, LEFT TO RIGHT: ROBIN MUIR, SANDY NAIRNE, PHILLIP PRODGER, BETTINA VON ZWEHL, NIRI SHAN.

THE JUDGES

CHAIR: SANDY NAIRNE
DIRECTOR, NATIONAL PORTRAIT GALLERY

With its quality of images and range of styles, the 2014 submission was as challenging to judge as any I have seen. The judges were often faced with a delightful dilemma as they debated between the merits and attractions of very diverse portraits, all of which are reviewed anonymously. But after sufficient discussion a consensus settled on the prize winners and also the works selected for exhibition. My thanks go to all photographers who submitted images, and my congratulations go to all those selected.

ROBIN MUIR
CURATOR AND CONTRIBUTING EDITOR TO *VOGUE*

I was honoured to make up one fifth of the jury panel, but trepidatious: the last I sat on, I was caught between three judges with such ferociously opposed viewpoints that the Chairman decided upon the winner unilaterally. This time, what a delightful process. My fellow judges were charming, forceful, passionate and articulate – much like the shortlist of photographs we formed, I think. The sheer volume of entries was daunting and our task was not made easy by their quality – for the most part extremely high. Naturally, those that best caught our individual attention satisfied the unspoken criteria we each had set ourselves. It was immensely gratifying that these chimed so easily and persuasively, one with the other, to produce, at length, winners of real merit.

PHILLIP PRODGER
HEAD OF PHOTOGRAPHS,
NATIONAL PORTRAIT GALLERY

The works in this year's exhibition are those that best captured the imaginations of the judges. Yet as I reflect on the judging process, I am struck by the outpouring of artistry, thought and feeling that all the entries represented. The pictures submitted this year were full of passion – for photography, for friends and loved ones, and, indeed, for humanity itself. So while my sincere congratulations go to those deserving photographers whose images appear on these pages, my heartfelt thanks go to all who submitted pictures. It was a privilege to view each and every one.

NIRI SHAN
PARTNER AND BUSINESS GROUP DIRECTOR,
TAYLOR WESSING LLP

I was delighted to be part of the judging panel this year and found the whole process enlightening, demanding, and, above all, inspirational. I learnt a lot about the technical aspects of photography – especially composition, style and lighting – from the other judges. The quality of the work was very high and I particularly enjoyed the variety of the images on show. Photographers from around the globe had submitted their work, which evidences the international esteem in which the competition is held. What I found most interesting about judging was that, despite the number and variety of the entries, the judges selected the prize winners fairly unanimously. I am very proud that Taylor Wessing is associated with such a worthy prize, and I hope you are inspired by the winners as much as I am.

BETTINA VON ZWEHL
ARTIST

The editing and selection of a handful of winning images from a total of over 4,000 had to be done on a swift and instinctual level. I found portraits of celebrities could be distracting when judged alongside those of anonymous sitters. To my surprise there was general agreement between the judges on the most outstanding images. My favourite portraits will stay in my memory – they did not win a prize, but I am glad they are part of the exhibition. Ultimately, we all have different criteria when choosing one portrait over another – this might be what the exhibition reflects.

FIRST PRIZE
DAVID TITLOW

A lazy midsummer morning spent with friends and family in the remote Swedish village of Rataryd provided the backdrop for David Titlow's winning entry in the 2014 *Photographic Portrait Prize*, which shows his nine-month-old son Konrad.

'My girlfriend, Sandra, is Swedish and we often visit a midsummer party with her old school friends,' explains Titlow. 'It was the morning after a big party and everyone was a bit hazy from the previous day's excess. I always try to have a camera with me, and as my girlfriend passed our son to friends on the sofa, the composition and backlight was so perfect that I had to capture the moment. The spontaneity of Konrad interacting with the dog and the beautiful Swedish sunlight flooding in from behind the sofa made the scene look like a painting.'

Titlow developed his interest in photography as a child in Halesworth, Suffolk, joining his school's camera club and learning how to process black-and-white film and print his own images. After attending Ipswich Art School, he enjoyed a successful stint in pop duo Blue Mercedes, who had several hits on the UK and US dance charts, before swapping his guitar for a camera in the early 1990s.

'Andy Warhol is one of my biggest inspirations; I love his Polaroid portraits and the darker themes in his work, such as the electric chair and Jackie Kennedy funeral prints,' he says. 'David Sims and Juergen Teller have been big influences too, along with the Sex Pistols, who completely changed my life.'

Now aged fifty-one, he is a regular contributor to *Vanity Fair*, *Esquire* and the *Guardian*, and believes his music background gives him an advantage when it comes to photographing the likes of Damon Albarn, Labrinth and Ed Sheeran.

'Most artists I have met seem to find having their picture taken quite distasteful and I can sympathise with that feeling, so I try to make it as painless as possible,' he says. 'The pressure with an editorial commission is that you only tend to be as good as your last shoot. The rewards are meeting interesting people, alongside the satisfaction of sometimes nailing a great portrait – not always easy when you have thirty minutes or an extremely awkward subject.'

Away from his editorial and advertising commissions, Titlow also pursues 'more eclectic' side projects, which he plans to self-publish in the future. His latest undertaking has seen him return to his former secondary school to photograph pupils wearing their preferred clothes instead of school uniform.

'I always enjoy trying to capture someone's true self on film and I want the children to have a picture that reveals their personality to their schoolmates, teachers and parents. It's an interesting juxtaposition to the anonymity of the traditional uniformed school portrait.'

Typically, Titlow shoots his professional commissions with a Nikon D800, while preferring his 'noisy and battered' Lumix GF1 for his personal work, including his portrait of Konrad, though in both cases he now largely works digitally.

'I have found the transition from film to digital very liberating; I have far more control over a shoot, both during it and in post-production,' he says. 'But as far as taking pictures is concerned, my philosophy remains the same as when I first picked up a camera: you never really know what is going to happen – it's pure magic.'
INTERVIEW BY RICHARD MCCLURE

TaylorWessing

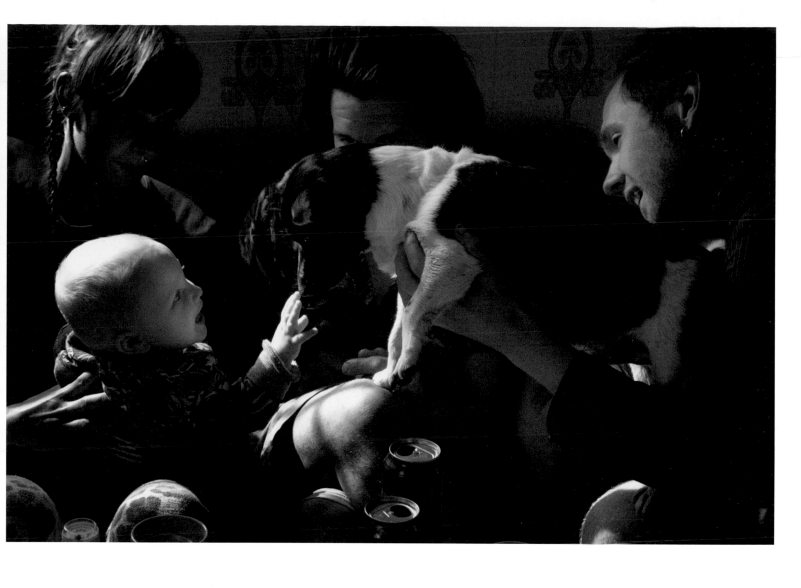

DAVID TITLOW
KONRAD LARS HASTINGS TITLOW
JUNE 2014

15

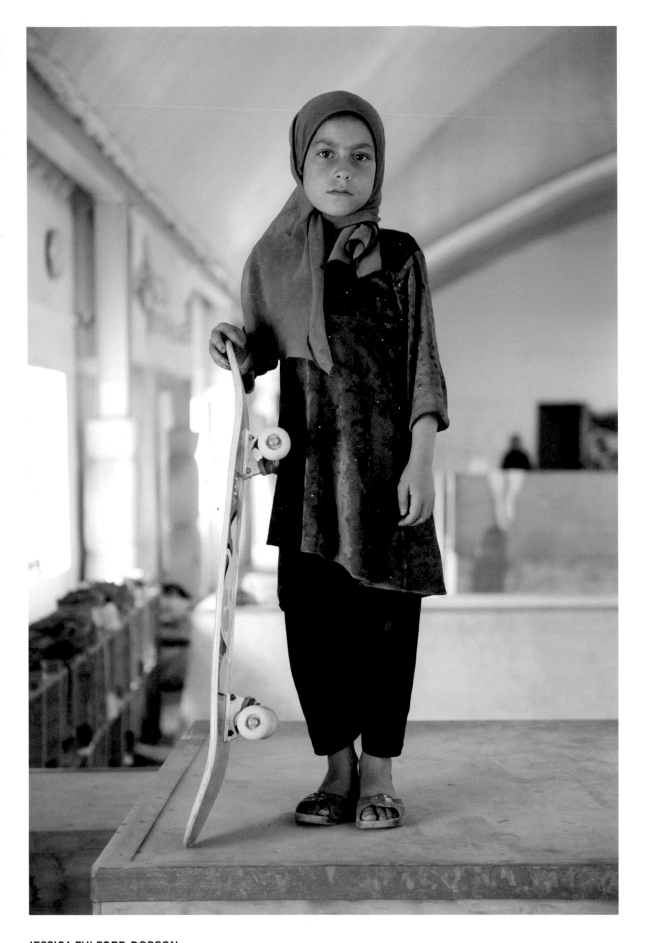

JESSICA FULFORD-DOBSON
SKATE GIRL
FROM THE SERIES *THE SKATE GIRLS OF KABUL*
MAY 2014

SECOND PRIZE
JESSICA FULFORD-DOBSON

In late 2012, London-based photographer Jessica Fulford-Dobson came across a short newspaper article about the work of Skateistan, a non-governmental organisation that uses skateboarding as a means of bringing creative arts and education opportunities to children in Afghanistan.

Intrigued by its mission statement to use skateboarding as a tool for empowering Afghan youth, Fulford-Dobson met with the NGO at its Berlin offices and was granted access to the Skateistan school in Kabul where pupils are provided with both skateboarding and classroom lessons. Around forty per cent of Skateistan students are female – a rarity in a country where women were banned from participating in sport until recently.

'Afghanistan is a very conservative country where women are difficult to gain access to, let alone photograph, so I concentrated on the young girls rather than the boys,' says Fulford-Dobson. 'Once I had got over the incongruity of watching girls skateboarding in flowing Afghan dress, I realised it was no different from photographing children anywhere else in the world doing something they loved.'

After her first visit in 2013 was cut short by Taliban violence that forced the temporary closure of the school, she returned in May to complete her portrait series *The Skate Girls of Kabul*, shooting digitally with a Nikon D800 and tripod. 'I have always preferred film. However, with the huge constraints one is presented with when photographing in a country such as Afghanistan, not to mention the very dusty conditions, digital enabled me to work fast and uninterrupted.'

Working within a confined space due to a lack of decent natural light, Fulford-Dobson took nine shots of her seven-year-old subject, allowing her to find her own pose in front of the lens. 'This was the last photograph I got of her before she had to run for the school bus,' she says. 'She is so immaculate-looking in a place that is always full of dust. Look at the way she has tied her headscarf so beautifully. She is so young, yet one can see so much experience in her firm, steady gaze.'

Fulford-Dobson turned to photography after assisting on a documentary about Linda McCartney. 'I was immediately drawn to the natural intimacy of Linda's work,' she recalls. 'Linda proved to be a significant influence on my work and I remain indebted to her for encouraging me to become a photographer. Soon after I bought my own basic Nikon camera – very similar to one of Linda's own Nikons – and enrolled on a photography course.'

Since then, Fulford-Dobson has worked for *Vogue* and the *Telegraph Magazine* and displayed her portraits and landscapes in galleries around the world, most recently in New York and Prague. She is currently organising an exhibition of *The Skate Girls of Kabul* to open in London next year.

'*Skate Girls* is without doubt the most rewarding project I have done,' she says. 'Some of the young girls told me how tired they were of the rest of the world viewing them with pity and seeing them as victims. They want the world to know that they are strong, and that they are capable of fighting for themselves. I feel happy that I have been able to help them.'
INTERVIEW BY RICHARD MCCLURE

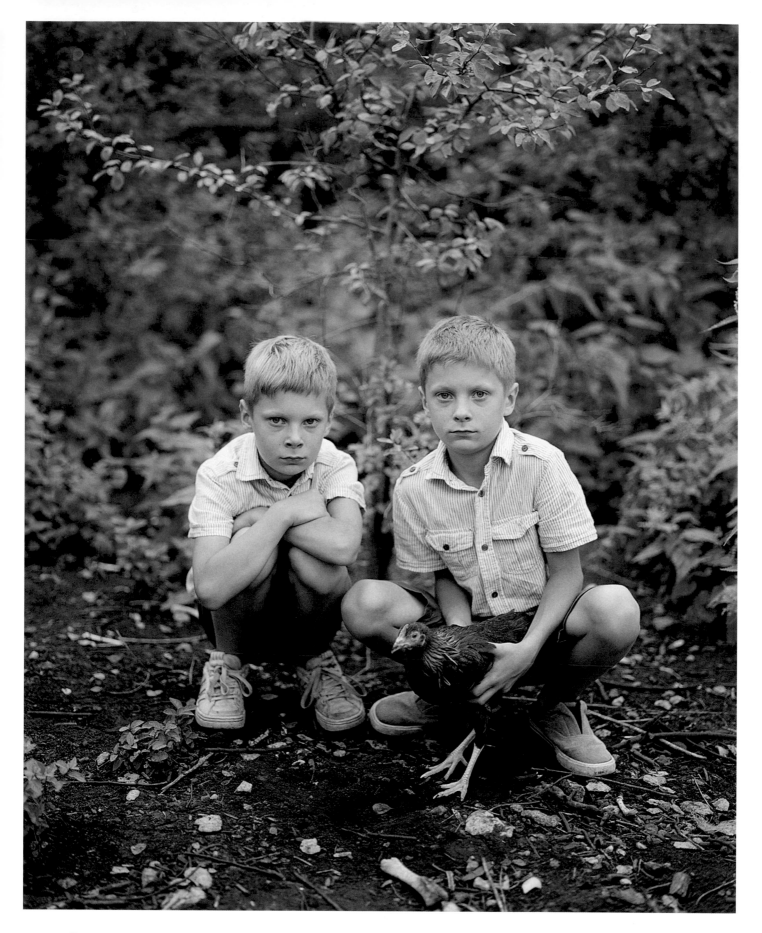

BIRGIT PÜVE
BRAIAN AND RYAN
FROM THE SERIES *DOUBLE MATTERS*
AUGUST 2013

THIRD PRIZE
BIRGIT PÜVE

Identical twins have provided striking subject matter for such renowned photographers as Diane Arbus and Mary Ellen Mark over the years – a tradition that is now continued by Birgit Püve and her image of nine-year-old brothers Braian and Ryan, pictured at their great-grandmother's country home in the Estonian town of Saue.

The portrait comes from Püve's book, *Double Matters*, which features more than eighty identical twins and triplets living in Estonia. The project involved months of research and miles of driving across the former Soviet republic.

'I wanted to explore the meaning of similarity and identity in a world that so much celebrates and adores uniqueness,' explains Püve, who is based in Tallinn. 'How do twins and triplets cope with that? How do they define or locate themselves? How does the idea of "another me" affect their relationship?'

Setting out to photograph her sitters in their homes or familiar everyday settings, she began the portrait-making process by talking at length with her subjects, scouting various locations and drawing preliminary ideas in a sketchbook. 'I try to find as much information about the sitters and the location as possible before every shoot,' she says. 'But I am also open to the higher powers, those opportunities that magically occur when an idea is ticking in my head. Often the final result is the mix of the drawn sketch and the real-life situation.'

For her entry, *Braian and Ryan*, she initially spent three hours with the boys, experimenting with different locations and backgrounds. Dissatisfied with the results, due to the poor-quality light, she returned two days later for a further session. 'This time, the boys had already become used to me, the light was perfect – all the pieces fitted together.'

Püve shot the portrait with a medium-format camera, working with film for its 'richness and depth' of image. 'You can't achieve the same with digital. Portraits shot on film are more alive and so spatial that it feels like you can step into the image,' she observes.

'This frame stood out for me. Ryan, born ten minutes earlier, tended to be more open and braver than his brother, and that aspect of their relationship is present in the photograph. It was like two sides of one person in the same image. They had a secret in them that we, single-borns, don't have.'

Aged thirty-five, Püve worked as a photo editor for weekly newspaper *Eesti Ekspress* for several years before starting out as a freelance photographer. Her portraits have been published in the *Washington Post* and the *Sunday Times Magazine*, while she was commissioned by the Estonian government to record US President Barack Obama's visit in September.

At present, she is also in the midst of several long-term portraiture projects, including *Estonian Documents*, in which a range of 'known and unknown Estonians' are pictured against a grey backdrop intended to act as a symbolic metaphor of Estonia's past, and *By the Lake*, which depicts Russian and Estonian villagers living either side of Lake Peipus.

'If you finally earn the trust of these communities, it feels like a gift and I am not afraid of projects that take time and effort,' she says. 'I'm interested in exploring ideas of the past and the identity of Estonians through my photography. Not all, but many of my projects deal directly with these themes, so probably there is something inside me, connected to memories or history, that I need to explore.'
INTERVIEW BY RICHARD MCCLURE

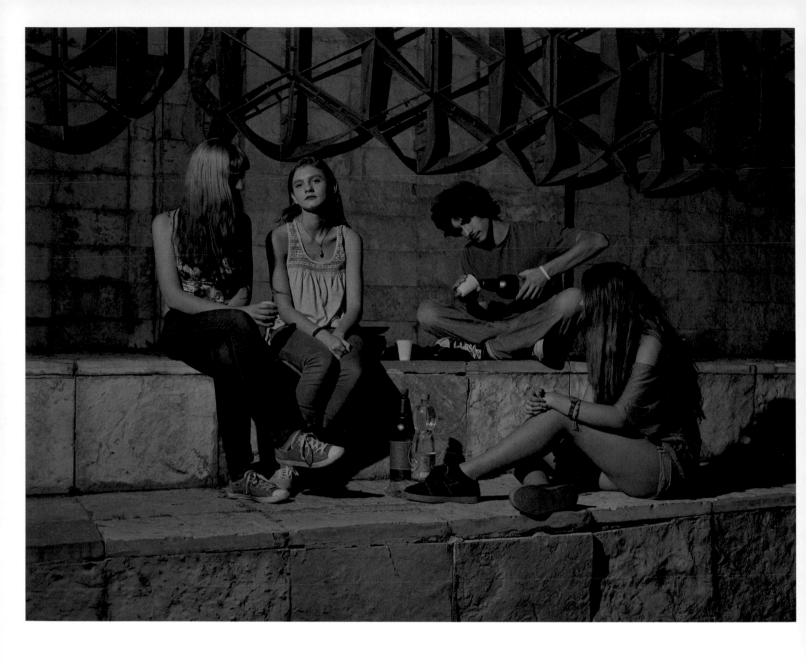

BLERIM RACAJ
INDECISIVE MOMENT
AUGUST 2013

FOURTH PRIZE
BLERIM RACAJ

Blerim Racaj was born in Kosovo in 1964 and has spent his entire photographic career documenting his homeland's social landscape. Since declaring independence from Serbia in 2008 following the devastation of the Balkans conflict and intervention by the United Nations, the fledgling republic has been plagued by high levels of unemployment. Its two million inhabitants make up the youngest population in Europe with half of the country under the age of twenty-five, though more than sixty per cent of those are currently jobless.

Racaj's portrait, *Indecisive Moment*, depicts four teenage friends – Rina, Edona, Dren and Likana – in front of Kosovo's national library in Pristina and is part of an ongoing project that was triggered by the bleak economic prospects facing Kosovo's youth.

'My inspiration has always been ordinary people – those who don't make the news,' says Racaj. 'I only know very basic information about the teenagers, which might sound slightly bizarre, but I prefer to know as little as possible about my sitters. I presume that their life stories might distort and interfere with my concept of the work, especially when I'm aware that almost every Kosovar is affected by painful traumas of the war, directly or indirectly.'

Racaj gained a BTEC Diploma in Photography from the City of Westminster College, graduating in 2006. He credits his time in London with providing a major influence on his work, and will shortly be returning to the University of Westminster to take his MA in Photography. 'Before studying in the UK, my work wasn't of any significance, but the cultural pulse of London had a great effect on me,' he says. 'Also, being introduced to the work of William Eggleston and Stephen Shore, among others, changed my way of seeing. I believe the philosophy in photography is an organic process that gets more complex over the years. Ten years ago, my entire focus was about aesthetic effect without any meaningful philosophical purpose.'

Seeking to denote the uncertain future for his teenage subjects in *Indecisive Moment*, Racaj departed from his usual large-format colour work. Instead, he used a medium-format rangefinder and black-and-white film with single flash to create a deliberately 'dark, mundane environment' during the two-hour shoot.

'I usually tend to have my presence in the process of photographing – the intense relationship between camera and the sitter is an important element in my work. In this instance, it was the opposite. I wanted to minimise my presence and the only way to achieve that was by taking more time photographing than I normally do. Eventually they got used to the shutter noise, flash and myself.'

The authenticity of the group's body language was an important element, he adds. 'At the beginning, I let them find their places, made them feel comfortable and then slightly manoeuvred their positions. The only exception was Dren, whose action was staged. His engagement pouring beer into a cup is an important element to the narrative, bringing a degree of dynamic into the frame while, compositionally, his forearm holding the bottle helps to lead the viewer's eye to the main character, Edona, and her arresting deadpan gaze.'

INTERVIEW BY RICHARD MCCLURE

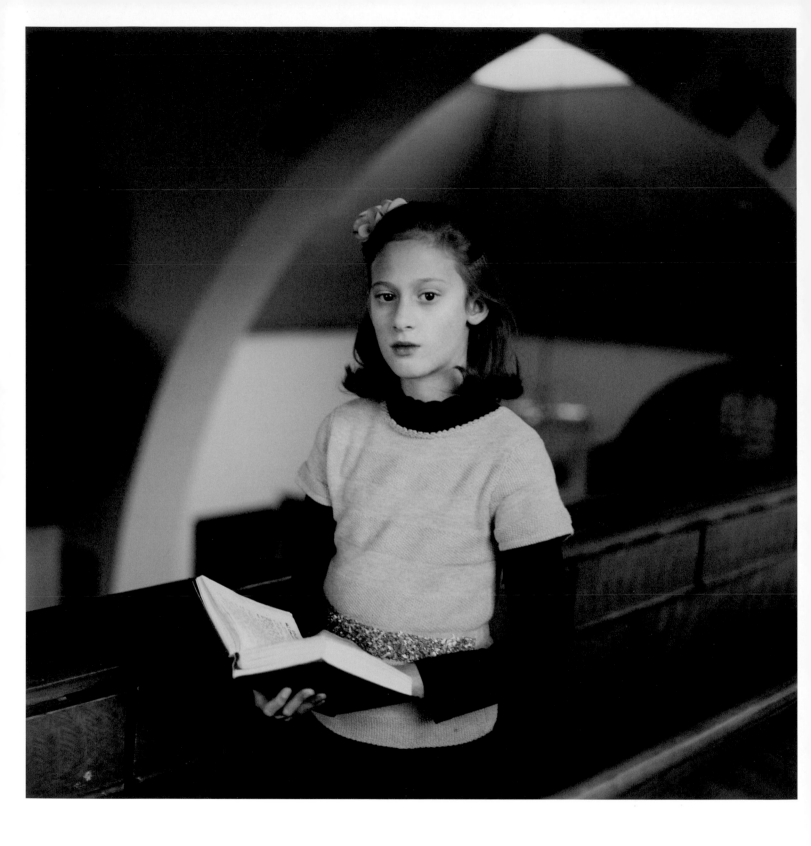

LAURA PANNACK
CHAYLA IN SHUL
FROM THE SERIES *PURITY*
JANUARY 2014

JOHN KOBAL NEW WORK AWARD
LAURA PANNACK

The recipient of this year's John Kobal New Work Award, presented to a photographer under the age of thirty whose work has been selected for the exhibition, is Laura Pannack. Her winning entry, *Chayla in Shul*, is taken from a long-term project, *Purity*, that focuses on Orthodox Jewish women and girls living in Stamford Hill, north London.

'*Purity* is something of a personal cultural quest; I am Jewish, but feel isolated from my local Jewish community,' explains Pannack, twenty-nine. 'Over the past three years I have gradually befriended local people who are kindly allowing me an insight into their lives and educating me about their Jewish faith and lifestyle. It is an extremely respectful project that I hope will portray the tradition, commitment and unique way these women live.'

Pannack photographed Chayla, whose father is a rabbi, at a local synagogue. After asking the youngster to wear pastel clothing in order to complement the building's interior, she composed the shot to allow an indication of her surroundings. 'I haven't often seen images taken in synagogues and I felt it was a relevant and visually striking place to capture her portrait. I positioned Chayla and directed her whilst importantly allowing her to relax, focus and engage. I wanted her to feel comfortable and empowered.'

As for all her non-commissioned projects, Pannack took the portrait with a Hasselblad 6 x 6 medium-format film camera. 'I could talk for hours about why I prefer analogue, but ultimately it alters my practice in allowing me to be more decisive, slow, focused and creative. I am also more precious with my frames.'

Pannack grew up in Surrey and studied painting at Central Saint Martins College of Art before first picking up a camera in her early twenties. Becoming 'instantly obsessed', she went on to gain a degree in editorial photography at the University of Brighton.

Much of her portfolio focuses on adolescents and young adults, including her personal project *Young Love*, a series depicting childhood sweethearts, and *The World of Boys*, an intimate photo-essay for *Time* magazine that addressed the vulnerability of teenage boys. 'I enjoy photographing young people because their energy, innocence and attitude is so refreshing,' she says. 'Their heightened emotions create an engaging experience.'

In 2010, she received first prize in the Portrait Singles category of the World Press Photo awards for her portrait of a young man recovering from anorexia, while recent work includes a study of child workers at a gold mine in Ghana for the *Telegraph Weekend* magazine, and a three-year-long personal project about young British naturists, for which she went unclothed in order to make her subjects feel at ease.

'Often my projects require me to gain trust from my subjects. I like to engage with those I work with, so I try to speak with them as much as I can,' she says. 'That was more difficult with Chayla, who is usually very shy around me. It was an intense shoot and her silence made me nervous. Despite this, I felt like we connected; there was a collaboration. Chayla has a strong and mature gaze, yet her innocence is still present. I hope that the portrait represents her well.'

INTERVIEW BY RICHARD MCCLURE

THE TAYLOR WESSING
PHOTOGRAPHIC
PORTRAIT
PRIZE
EXHIBITORS

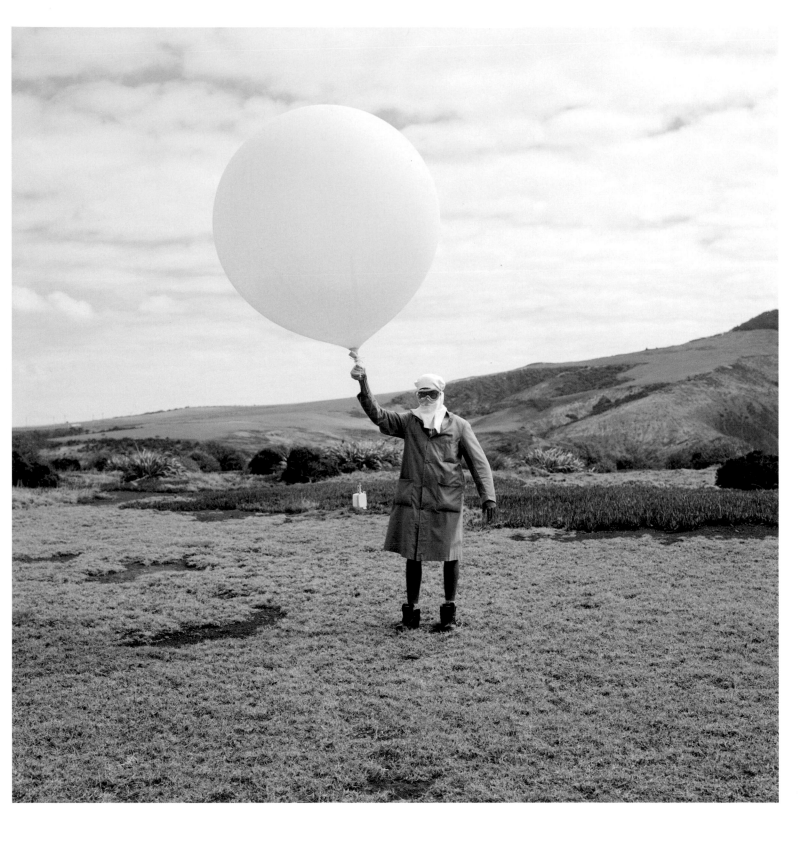

JON TONKS
MARCUS HENRY, METEOROLOGICAL STATION, ST HELENA ISLAND
FROM THE SERIES *EMPIRE*
MAY 2013

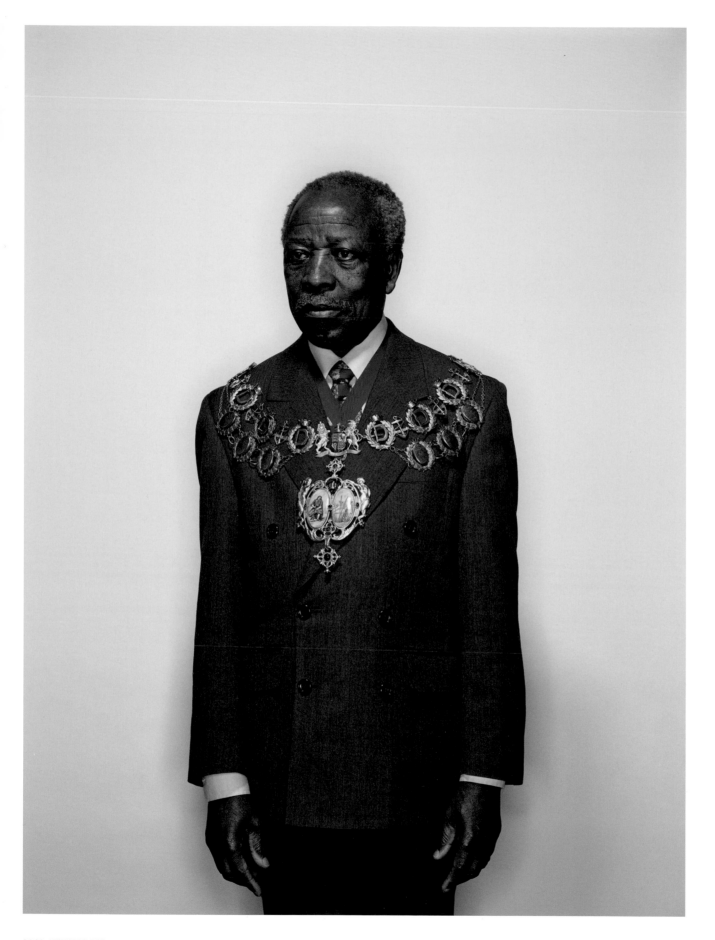

IAN ATKINSON
LEWISHAM CHAIR OF COUNCIL, CLLR OBAJIMI ADEFIRANYE
FROM THE SERIES *THE LONDON BOROUGH MAYORS 2013–2014*
JANUARY 2014

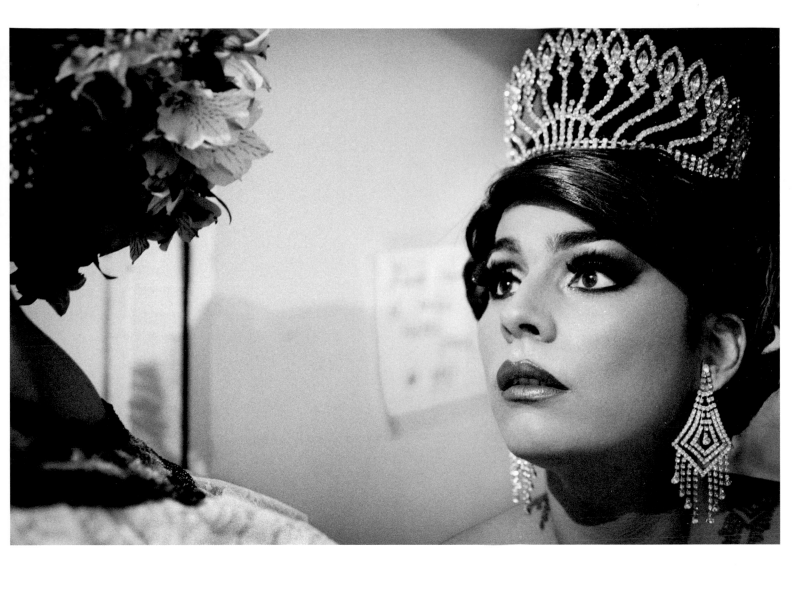

VIVIANA PERETTI
NATALY ANGEL MIRANDA
FROM THE SERIES *DANCING LIKE A WOMAN*
JULY 2013

27

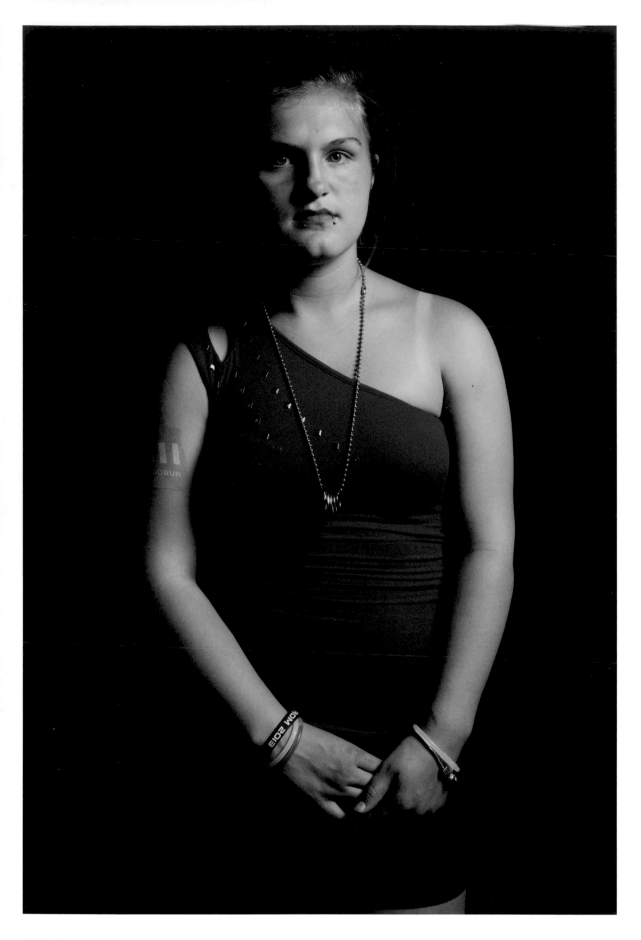

ZOE PERRY-WOOD
KAITLYN
FROM THE SERIES *THE BAGLY PROM*
MAY 2013

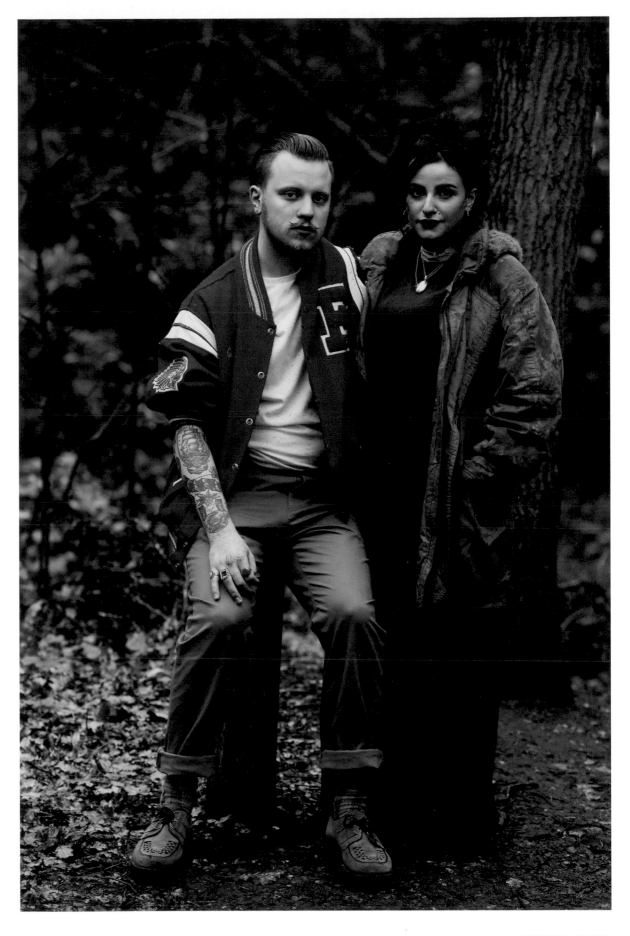

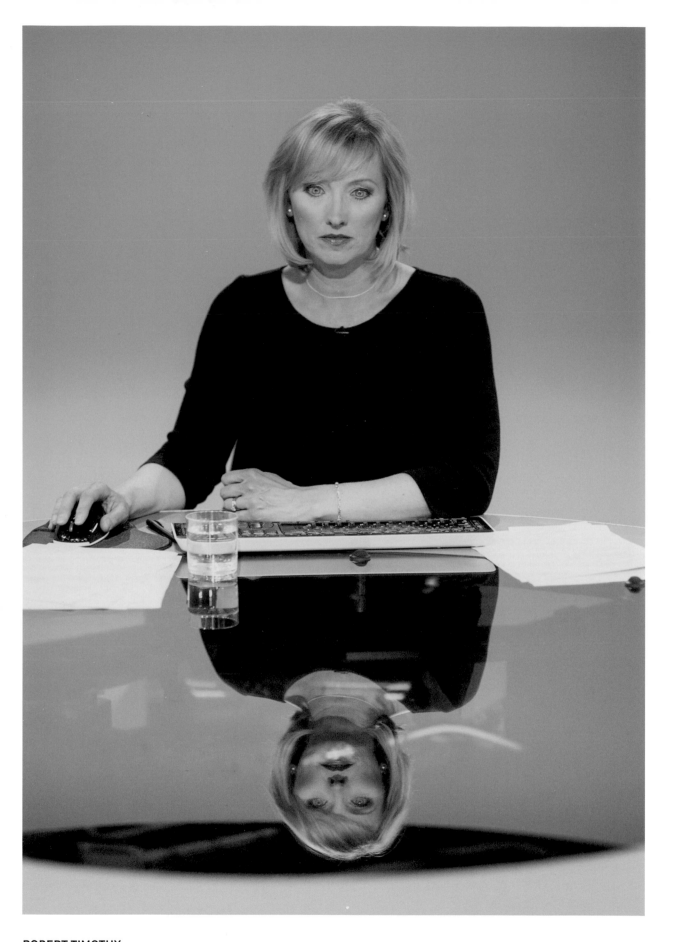

ROBERT TIMOTHY
MARTINE CROXALL
FROM THE SERIES *ONE MINUTE TO GO ...*
MAY 2014

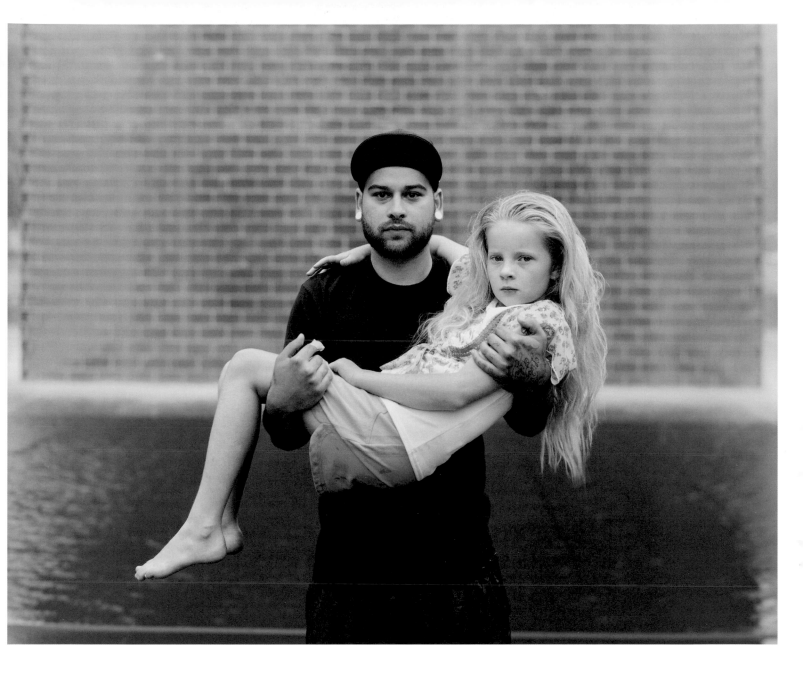

RICHARD RENALDI
CHRIS AND AMAIRA, CHICAGO, 2013
FROM THE SERIES *TOUCHING STRANGERS*
JUNE 2013

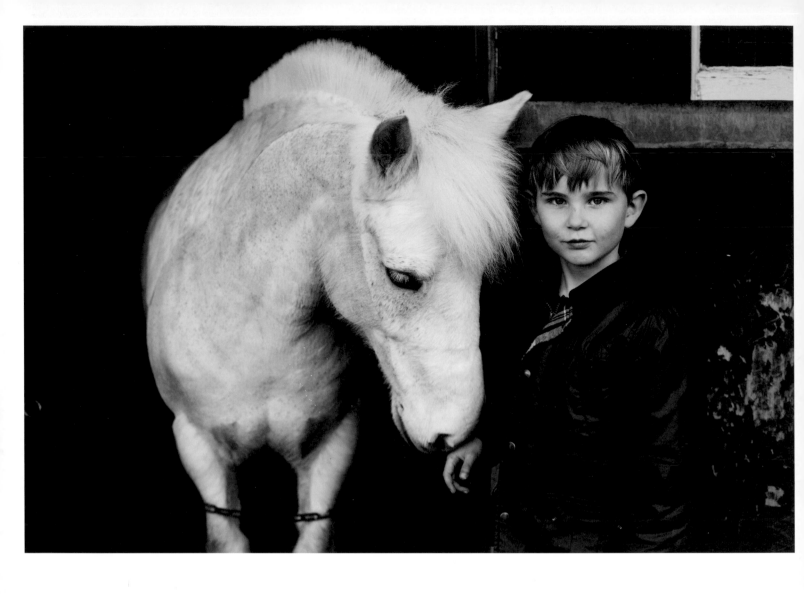

TRACY HOWL
FELIX
FEBRUARY 2014

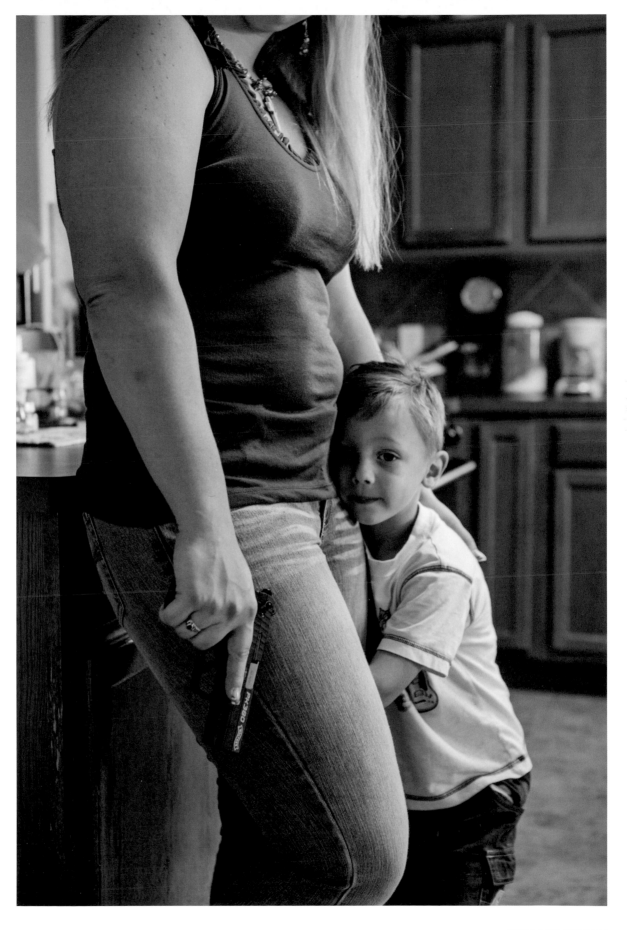

SHELLEY CALTON
JENIFFER
FROM THE SERIES *CONCEALED, SHE'S GOT A GUN*
MAY 2013

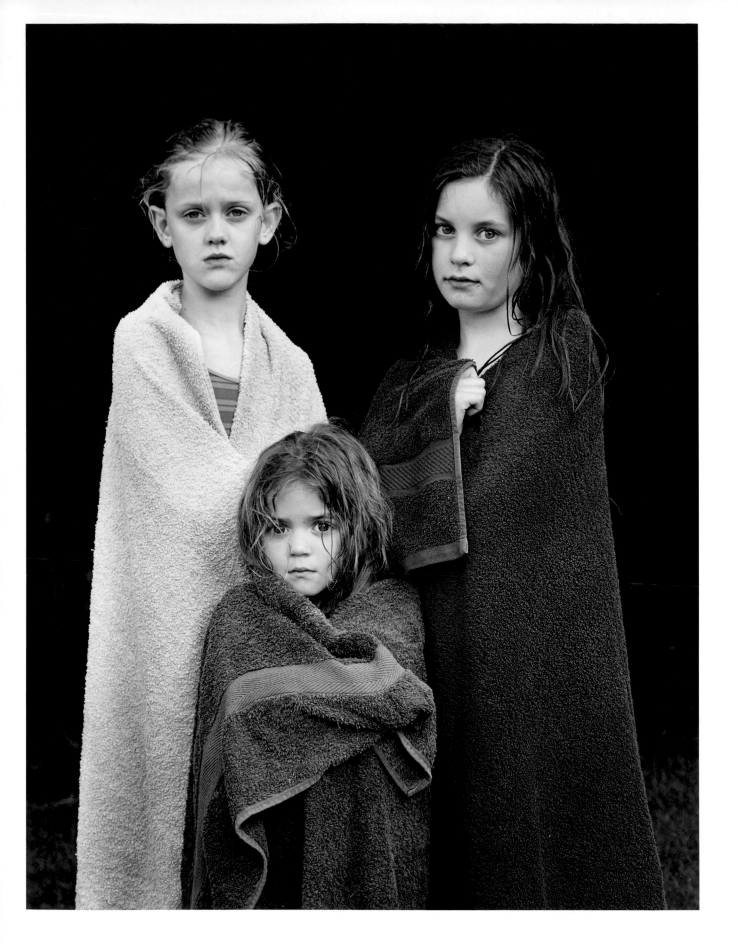

CHRIS FRAZER SMITH
DRYING OFF
MAY 2014

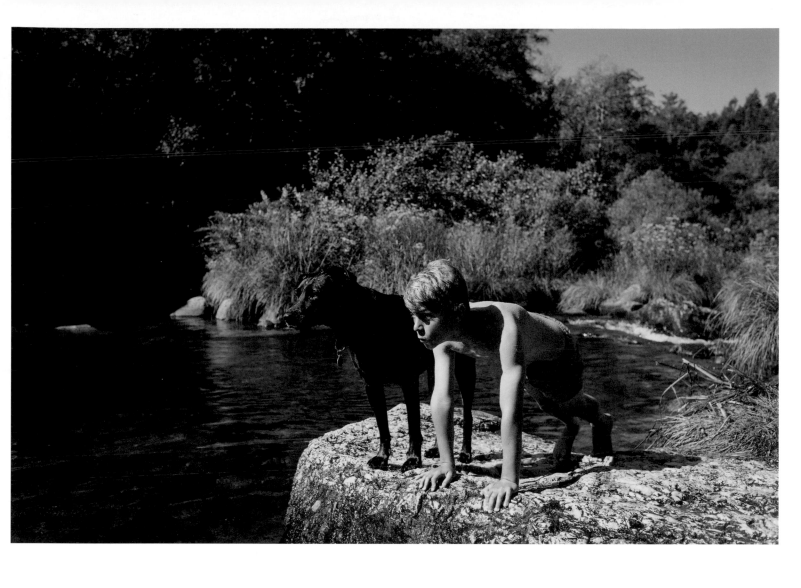

OFFER GOLDFARB
ERIK, SOFTWARE TEAM LEADER
FROM THE SERIES *OUR STAFF I/O*
MARCH 2014

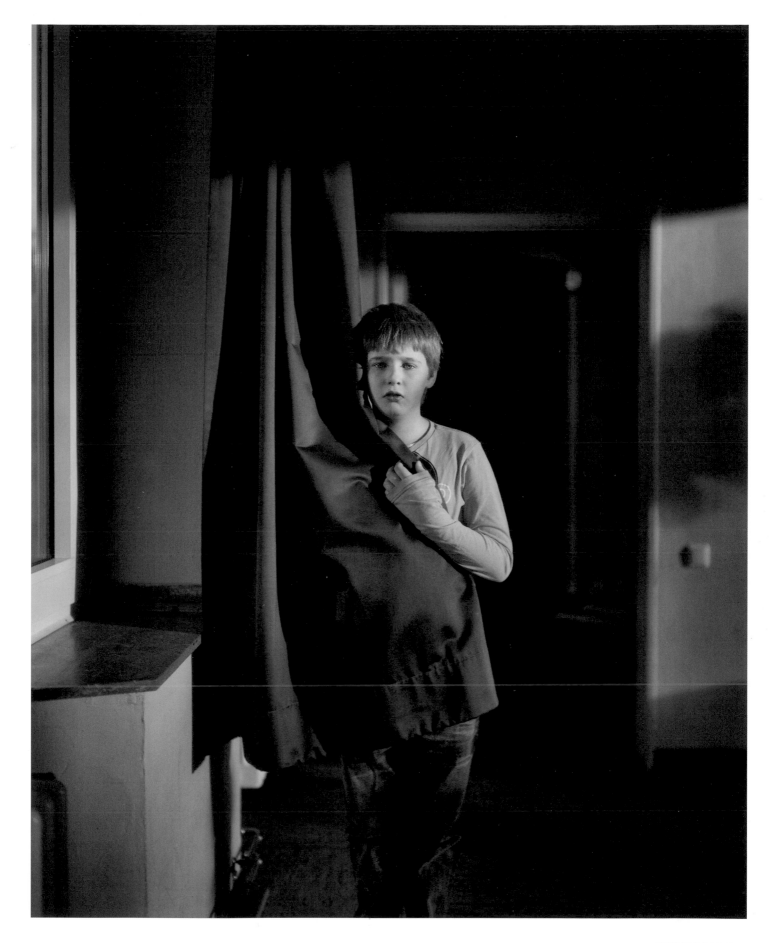

HEIKO TIEMANN
BOY WITH DRAPE
FROM THE SERIES *INFLICTION*
MARCH 2014

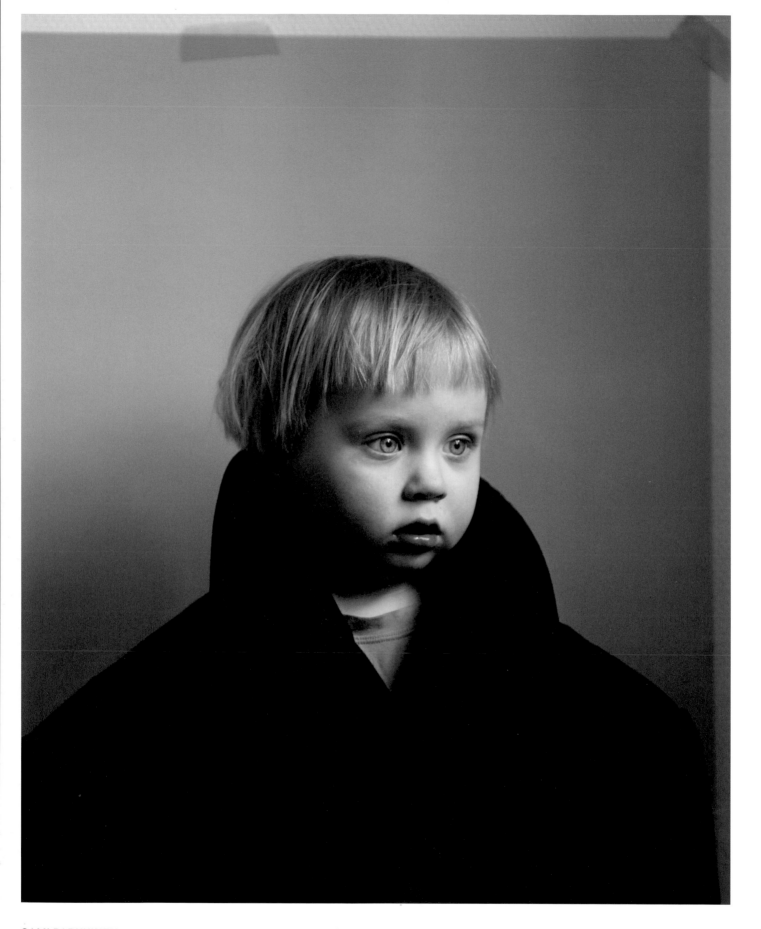

SAMI PARKKINEN
ARVI
FROM THE SERIES *FATHER AND SON*
MARCH 2014

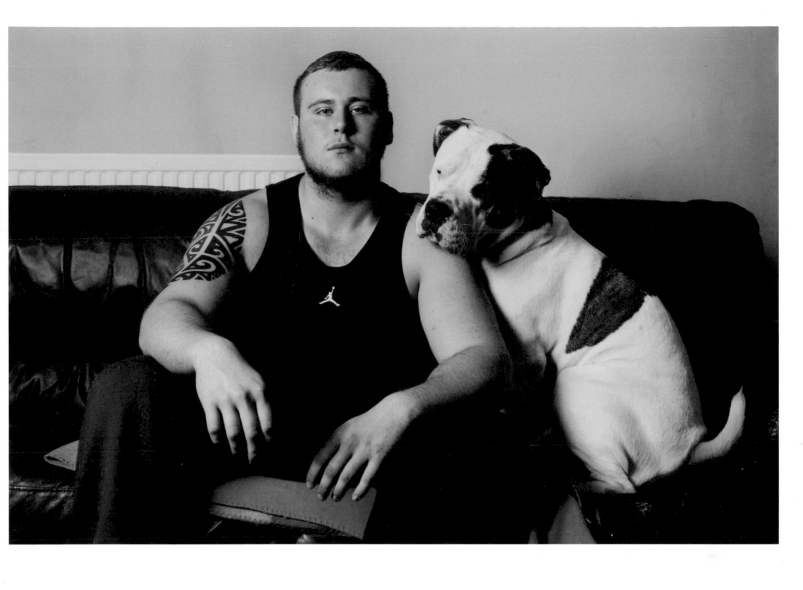

JILL WOOSTER
WITH REG
FROM THE SERIES *SAY HELLO TO MY LITTLE FRIEND*
JULY 2014

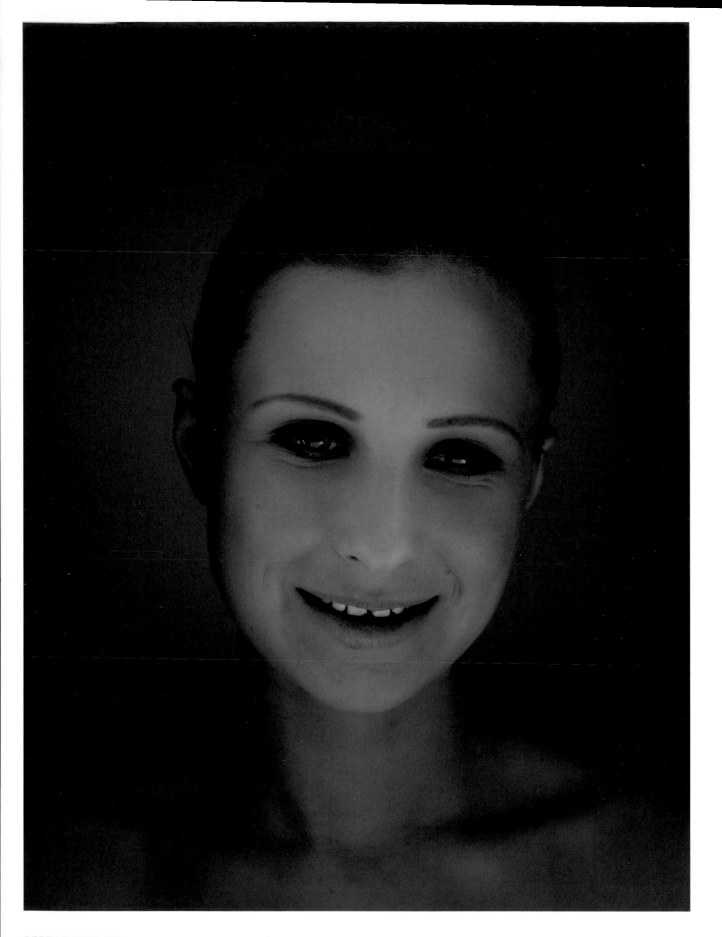

BERT VERWELIUS
MARIA
FROM THE SERIES *PUSSY RIOT UNMASKED*
JANUARY 2014

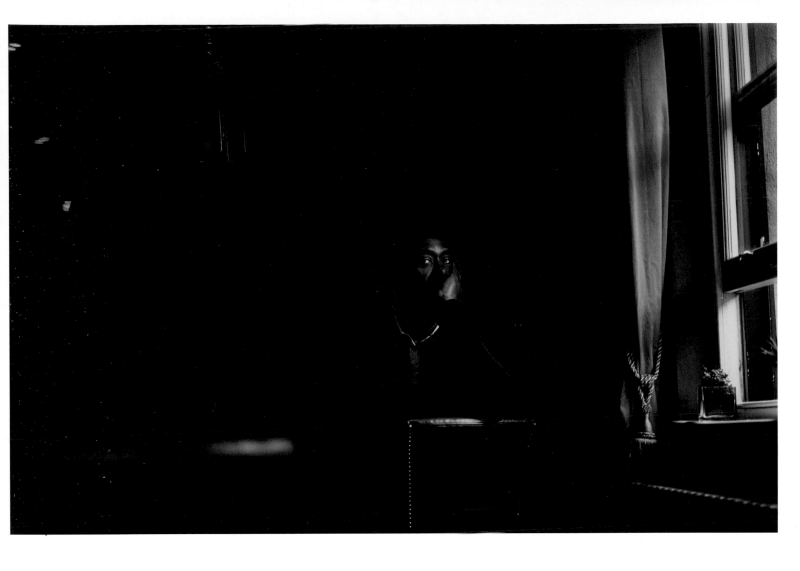

SARAH LEE
LENNY HENRY
JUNE 2014

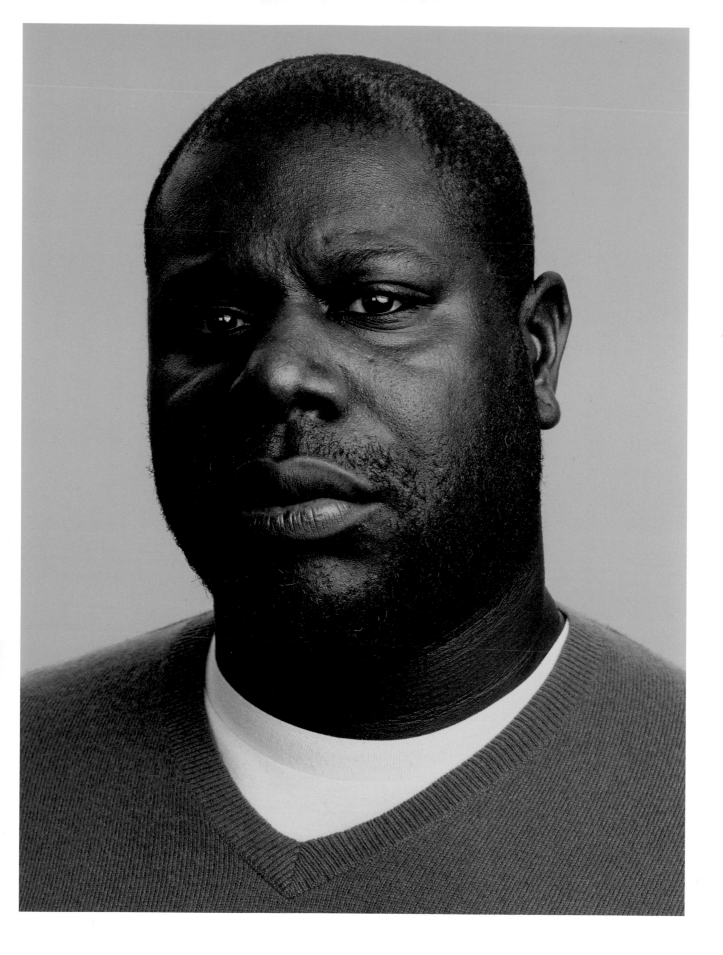

GILES PRICE
STEVE MCQUEEN
SEPTEMBER 2013

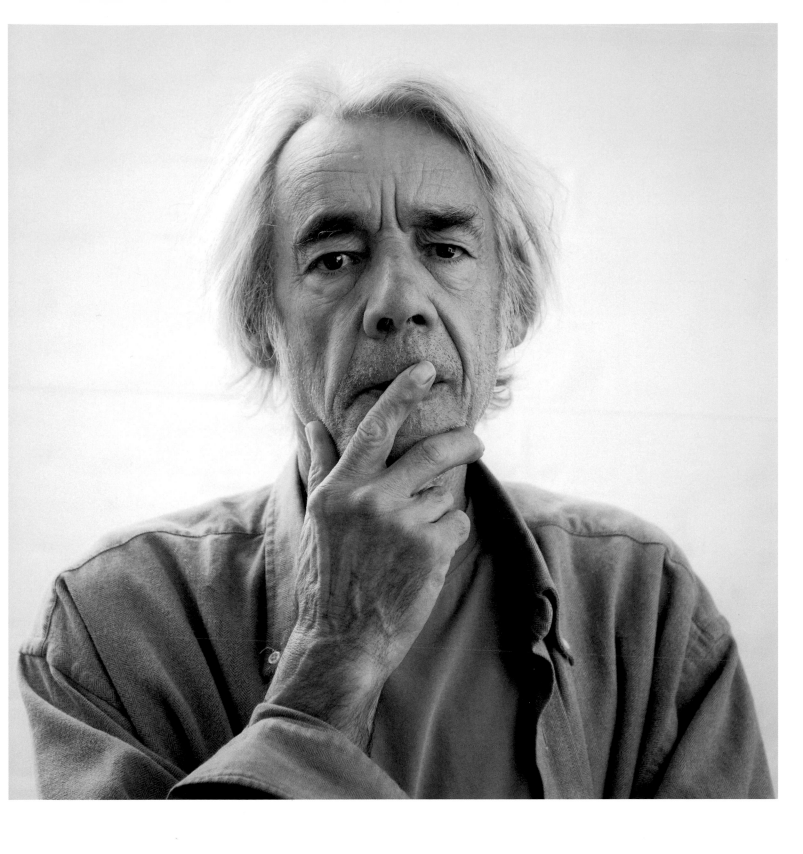

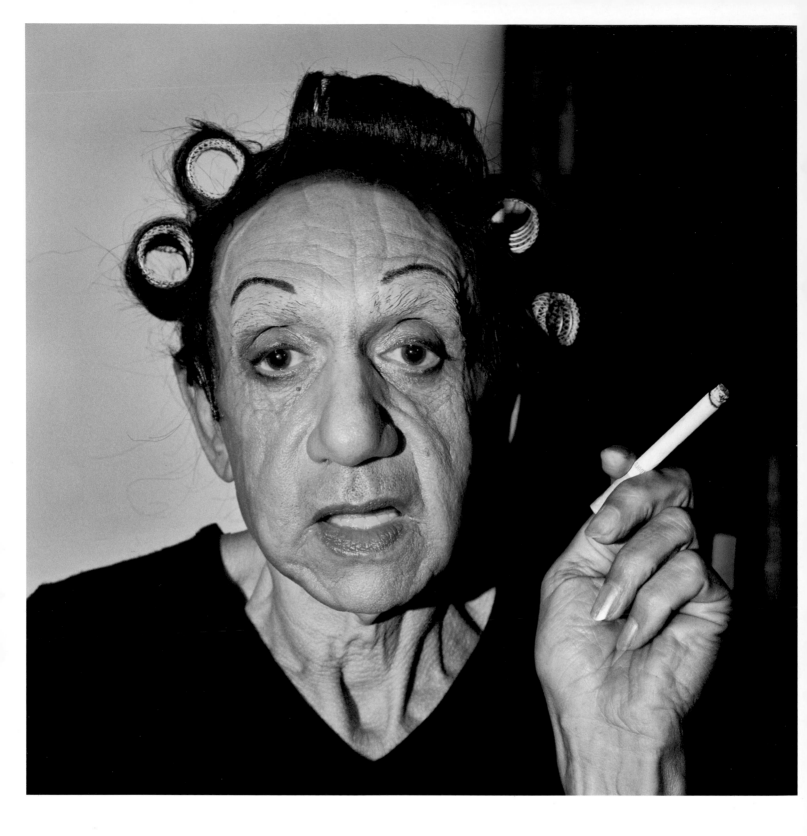

CATHERINE BALET

47 YEARS LATER (A TRIBUTE TO DIANE ARBUS)
FROM THE SERIES *LOOKING FOR THE MASTERS IN RICARDO'S GOLDEN
SHOES IN COLLABORATION WITH RICARDO MARTINEZ PAZ*
OCTOBER 2013

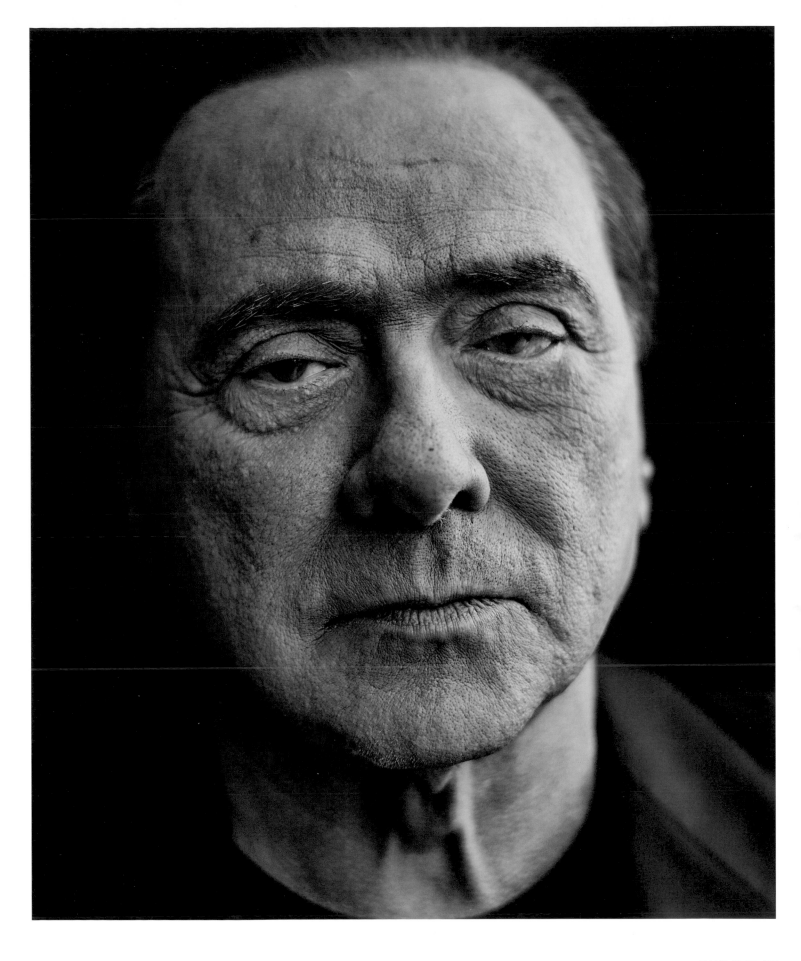

PAUL STUART
SILVIO BERLUSCONI
JANUARY 2014

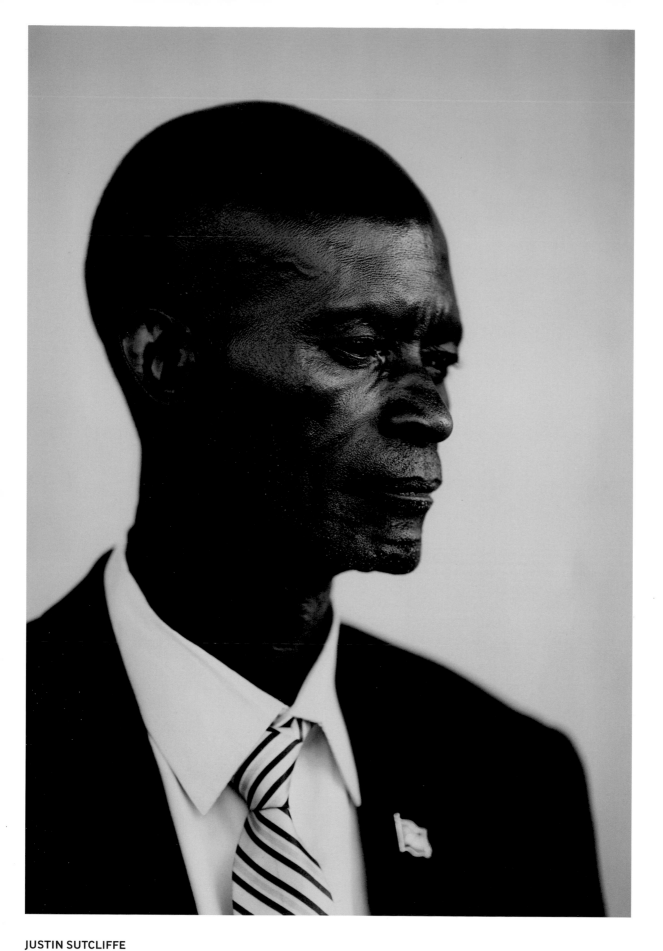

JUSTIN SUTCLIFFE
LOCAL GOVERNMENT OFFICIAL
FROM THE SERIES *DEMOCRATIC REPUBLIC OF CONGO*
OCTOBER 2013

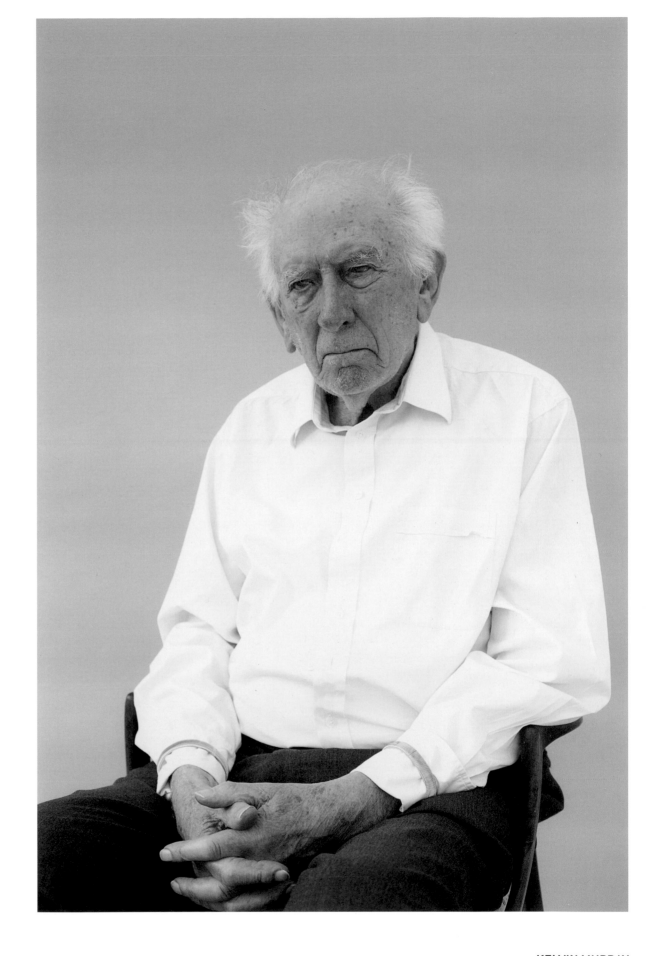

KELVIN MURRAY
DAD
SEPTEMBER 2013

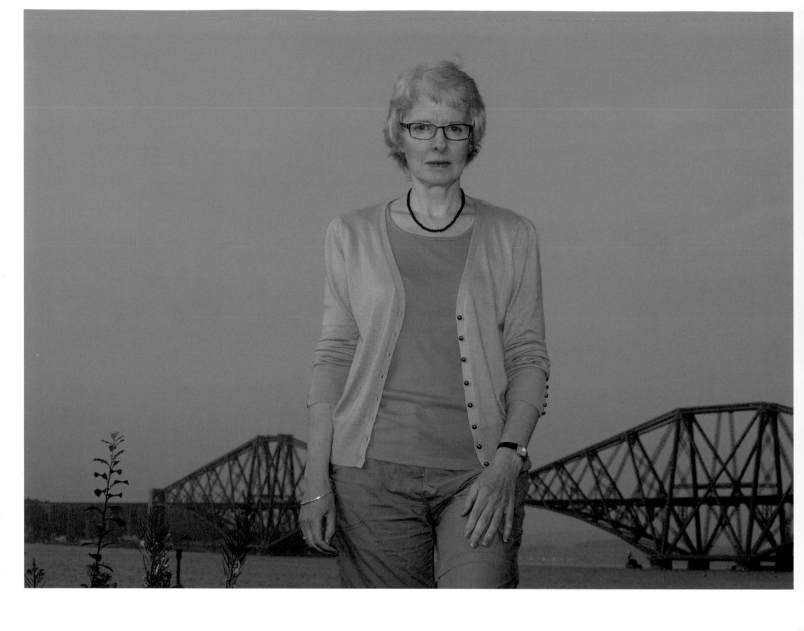

ELAINE VIZOR, MA
EH4
FROM THE SERIES *NOW YOU SEE ME …*
AUGUST 2013

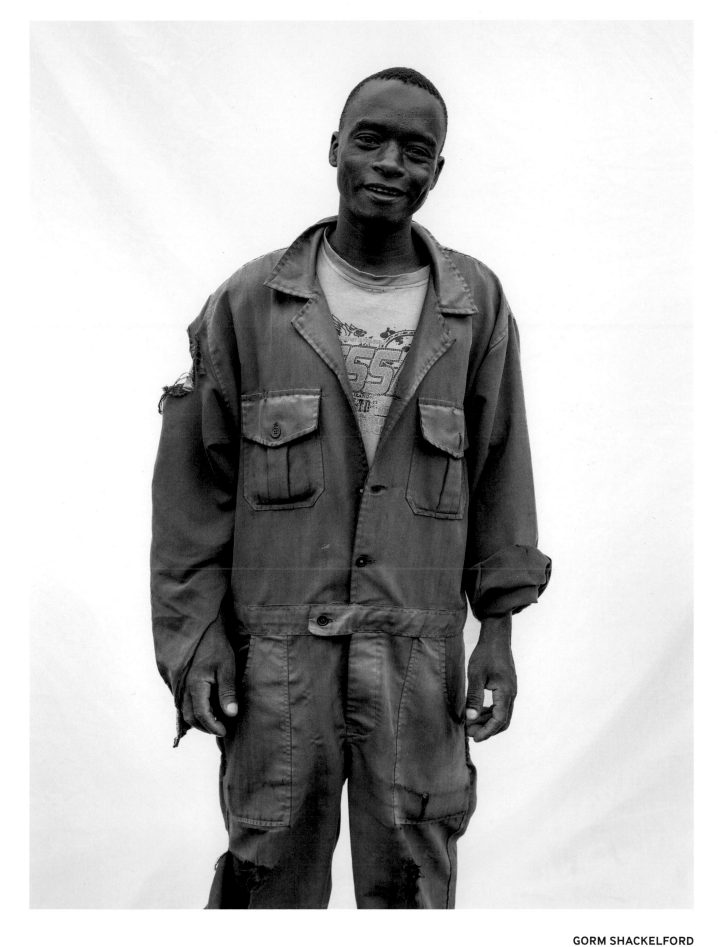

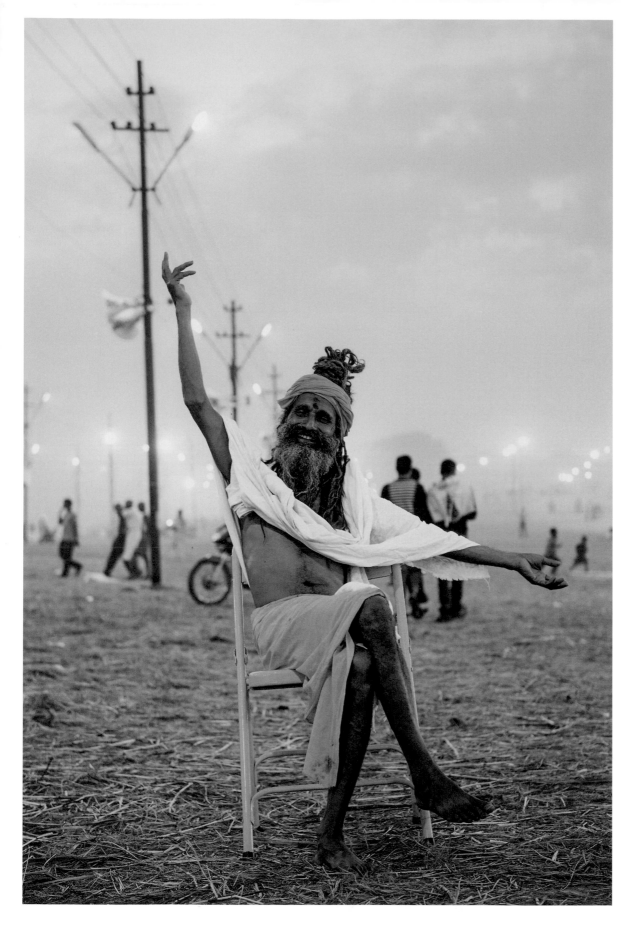

KARAN KUMAR SACHDEV
VIJAY RUDANLALJI BANSPAL
FROM THE SERIES *THE YELLOW CHAIR PORTRAITS*
FEBRUARY 2013

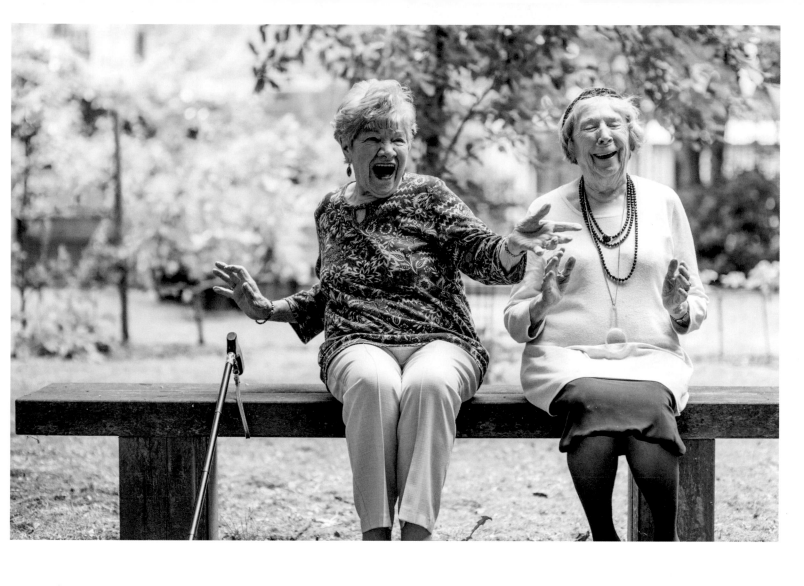

NEIL RAJA
DOLLY & CO.
JUNE 2014

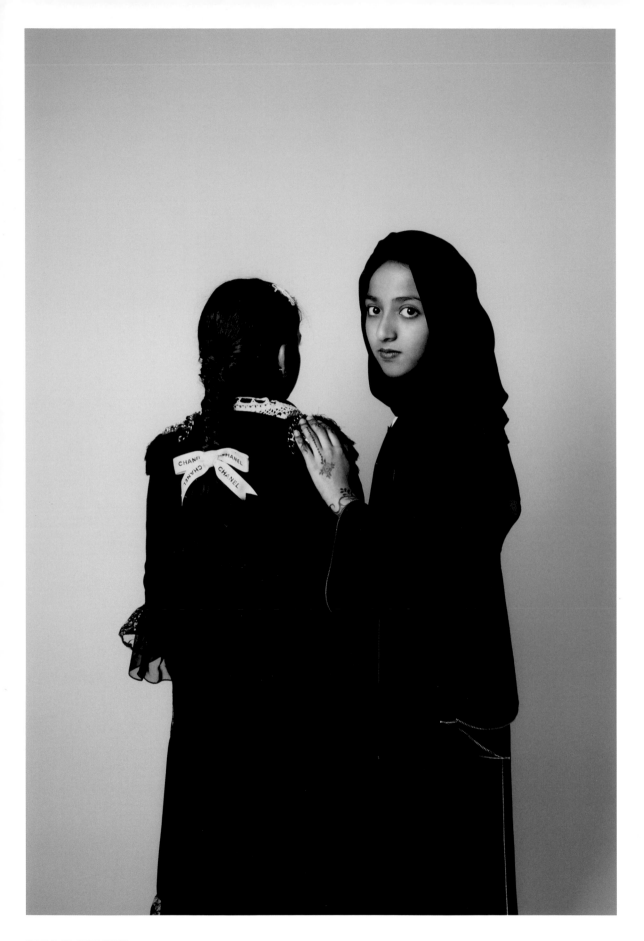

SARA AL OBAIDLY
TOGETHER WE STAND
FROM THE SERIES *QATAR: OLD HEARTS, NEW WORLD*
JUNE 2014

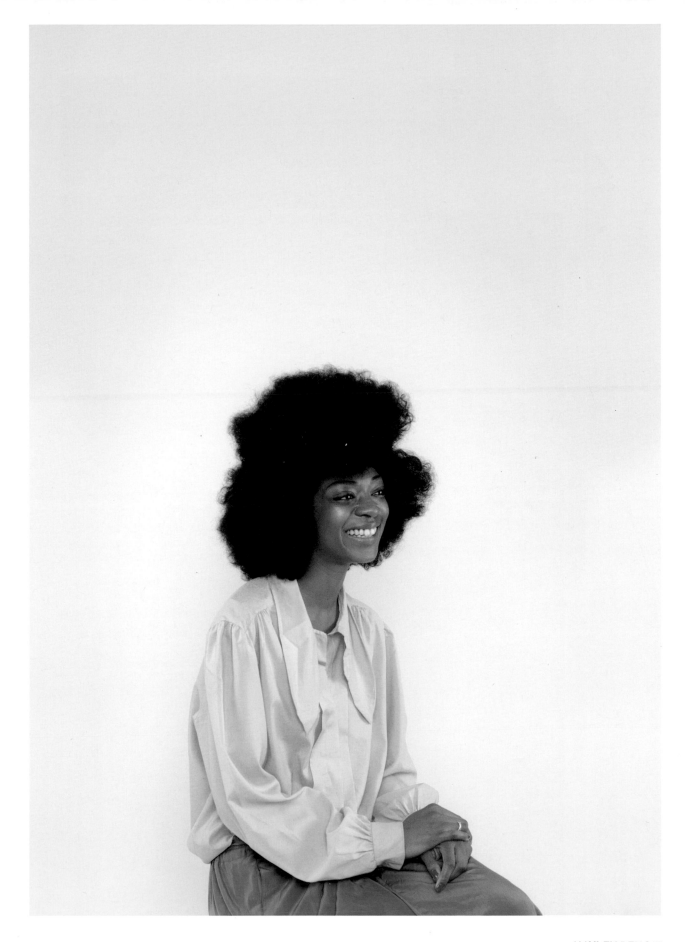

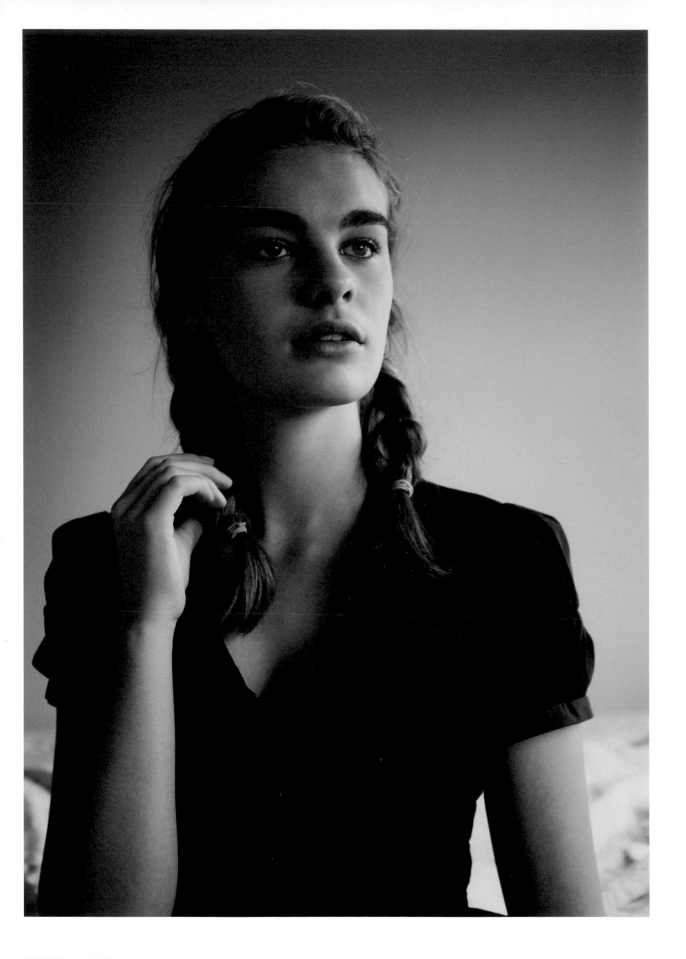

MICHELE ABOUD
STELLA
MAY 2014

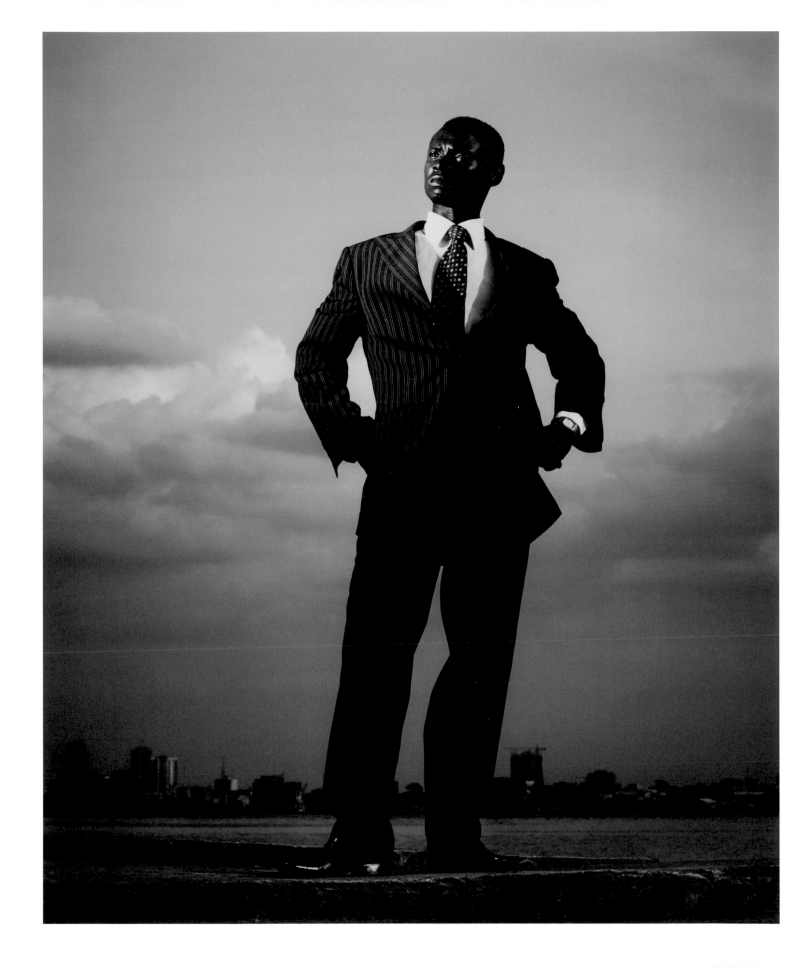

MARK READ
SAPEUR, BRAZZAVILLE
FEBRUARY 2014

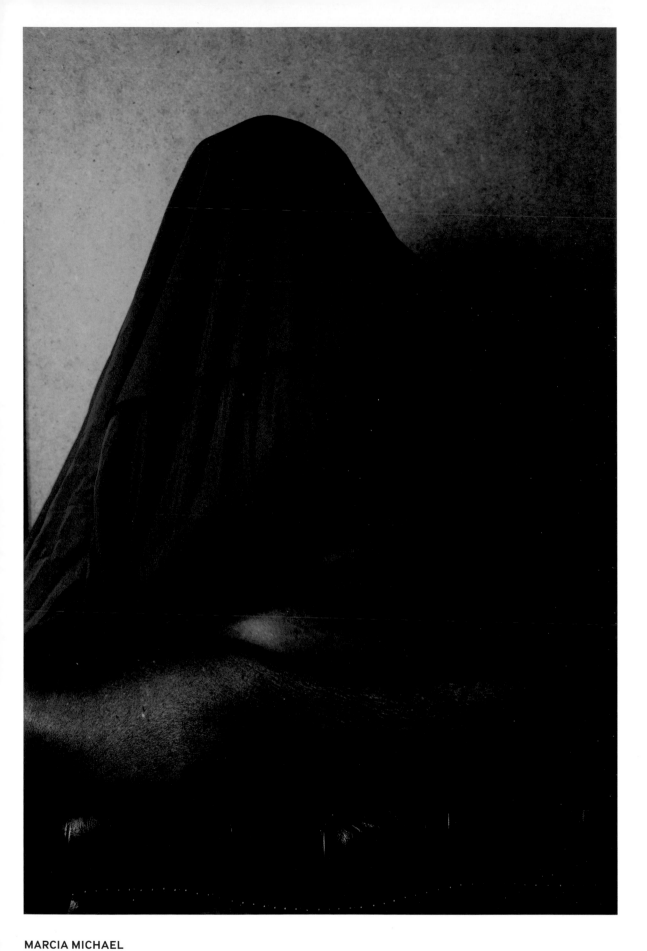

MARCIA MICHAEL
MYRTLE MCKNIGHT, MY MOTHER
FROM THE SERIES *THE OBJECT OF MY GAZE*
APRIL 2014

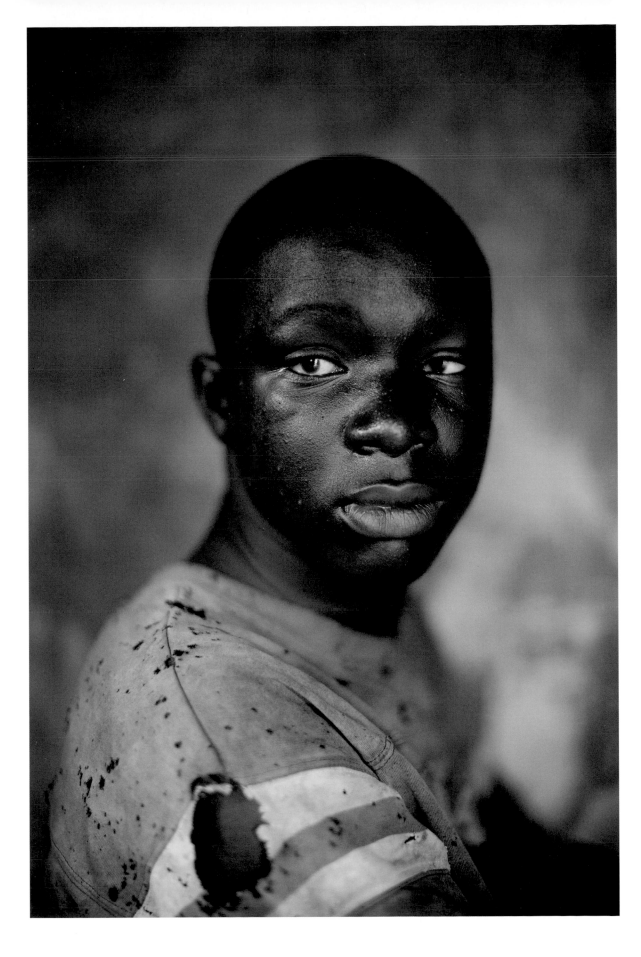

GRAEME ROBERTSON
BLIND BOY IN VILLAGE HUT
MARCH 2014

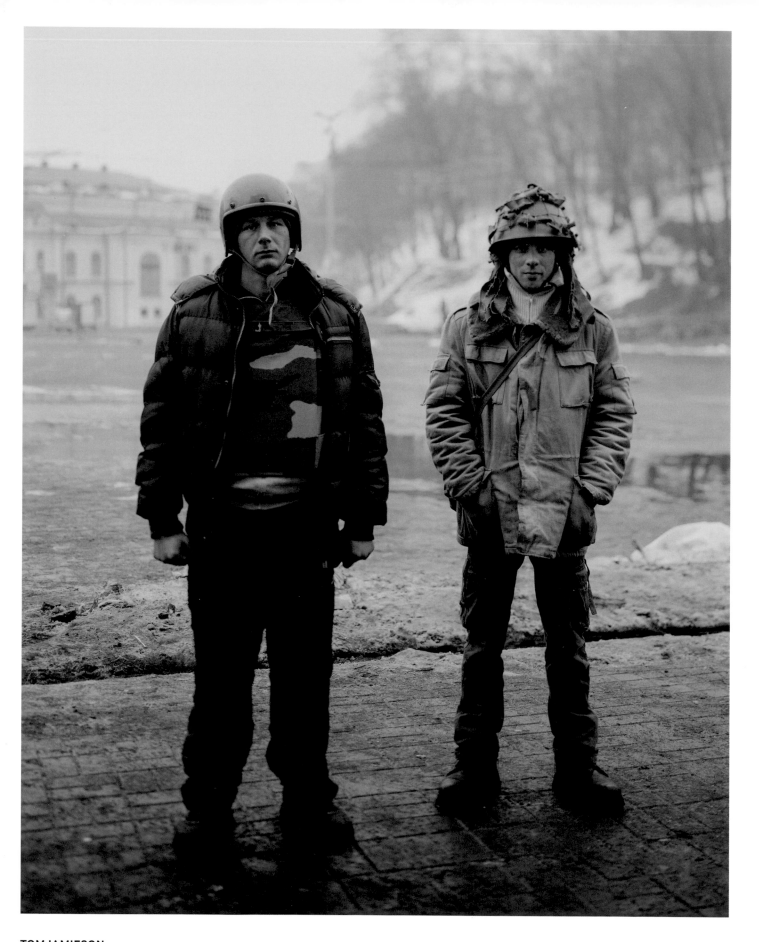

TOM JAMIESON
EUROMAIDAN PROTESTORS IN KYIV, UKRAINE
FROM THE SERIES *MAIDAN*
FEBRUARY 2014

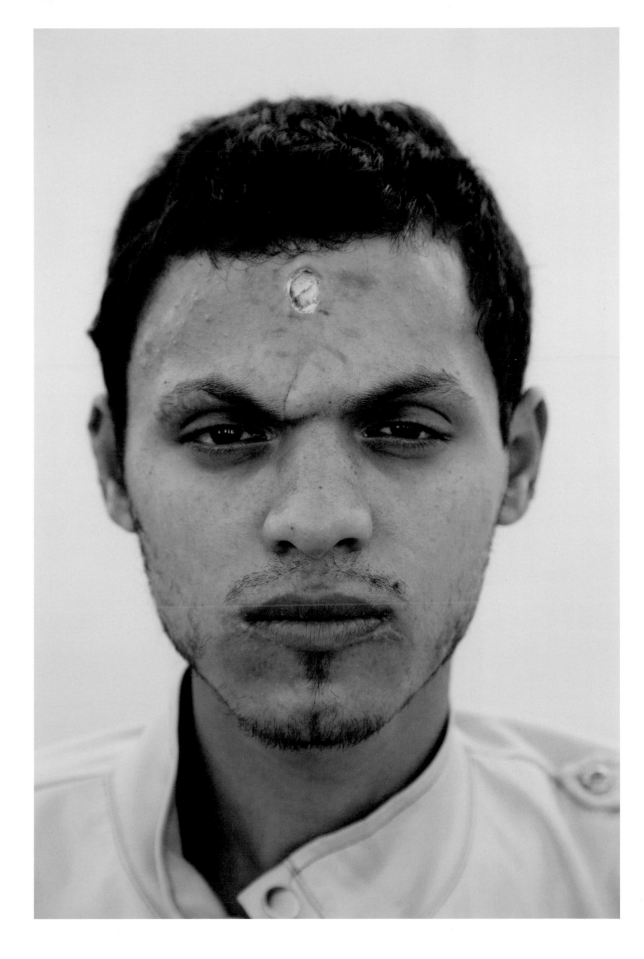

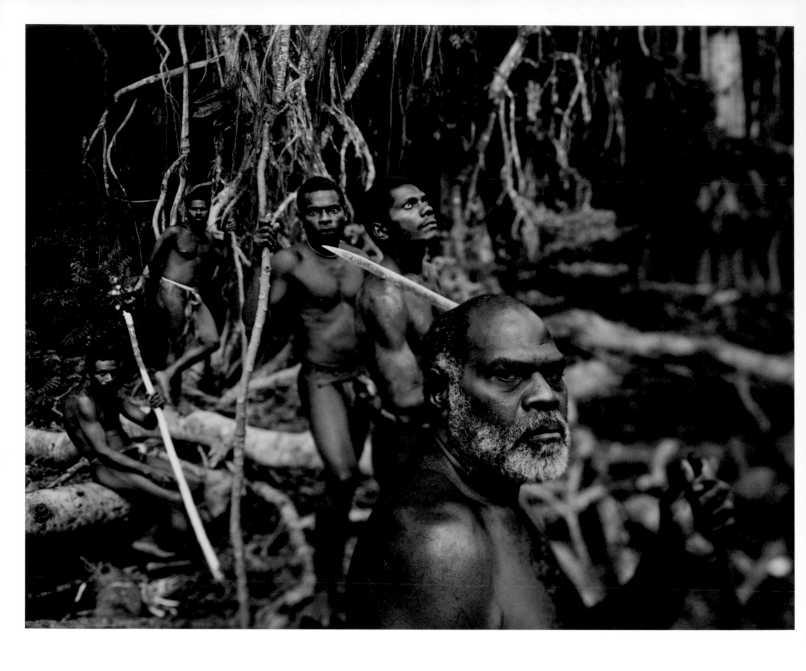

TOMASZ GUDZOWATY

CHIEF ALEXANDRE FROM RANGUSUKSUK, PENTECOST ISLAND, WITH HIS TRIBESMEN
FROM THE SERIES *DAREDEVILS OF VANUATU*
JUNE 2013

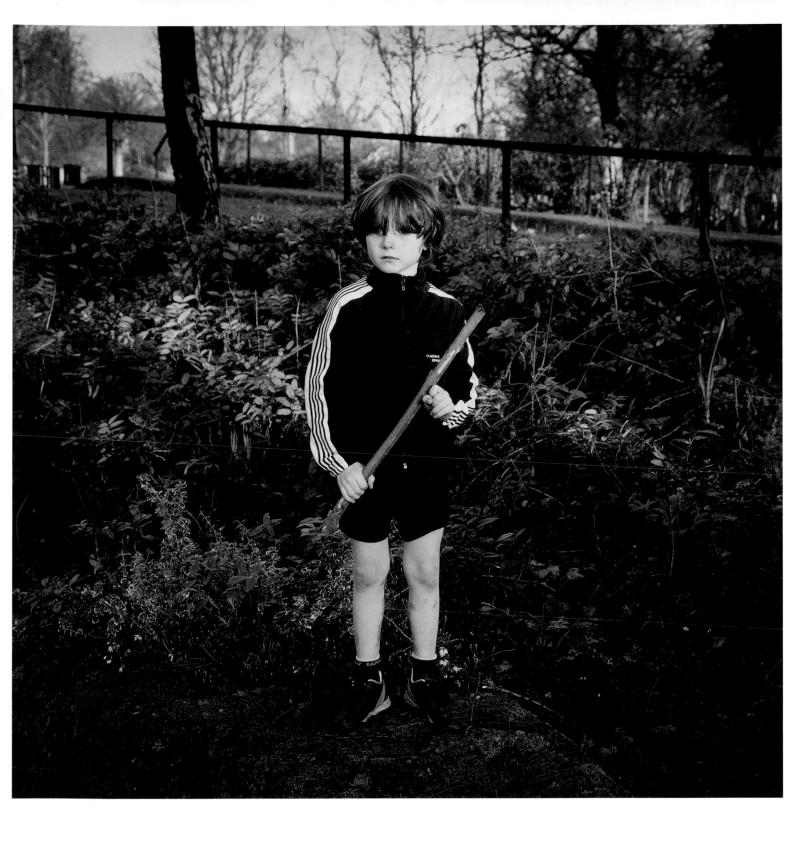

MARGARET MITCHELL
BOY WITH STICK GUN PLAYING WORLD WAR III ('RUSSIA VERSUS UKRAINE')
MARCH 2014

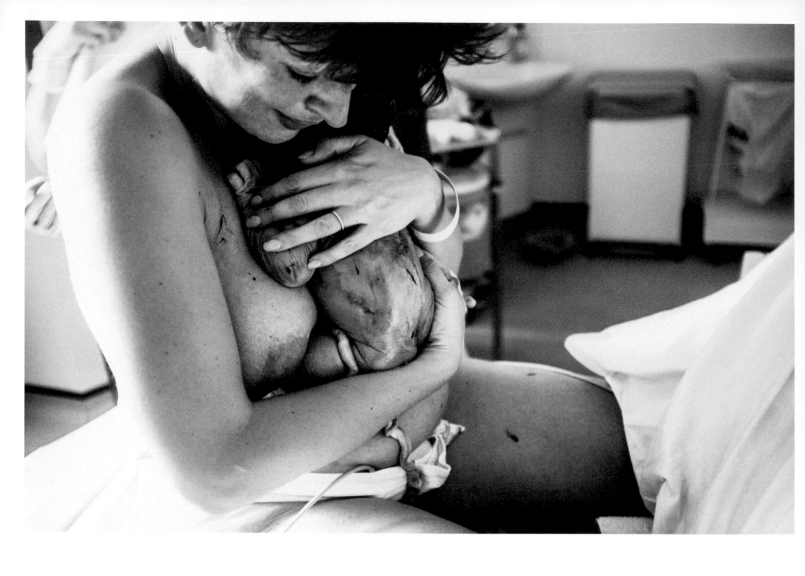

BUKI KOSHONI
EMBRACE
FROM THE SERIES *ACE & MARIANNE*
JUNE 2014

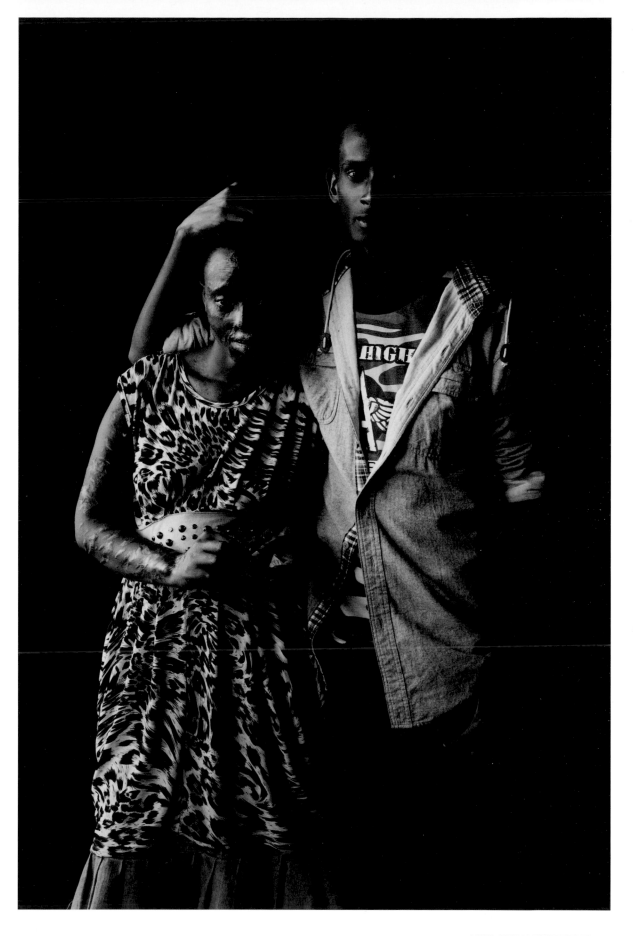

ANN-CHRISTINE WOEHRL
CHRISTINE AND MOSES
FROM THE SERIES *IN/VISIBLE*
MARCH 2014

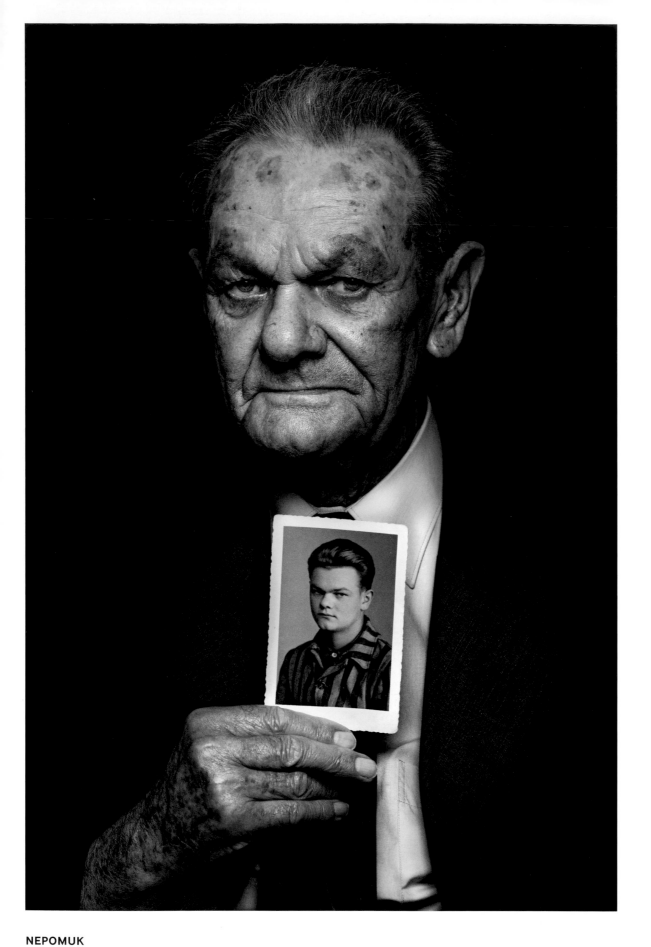

NEPOMUK
JACEK Z.
FROM THE SERIES *NOT GUILTY*
JANUARY 2013

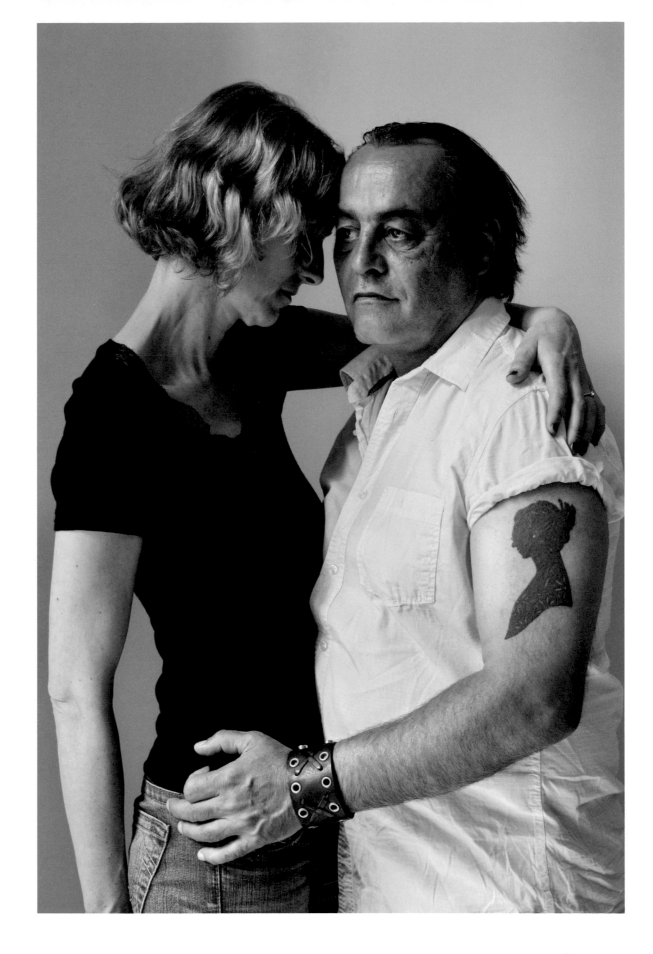

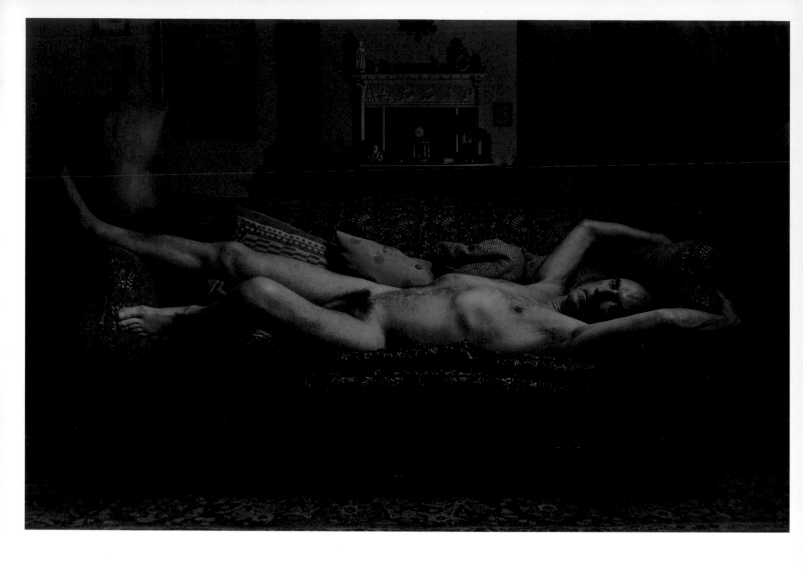

LAURA STEVENS

TIM

FROM THE SERIES *OVER THE HILL: A PHOTOGRAPHIC JOURNEY*

APRIL 2014

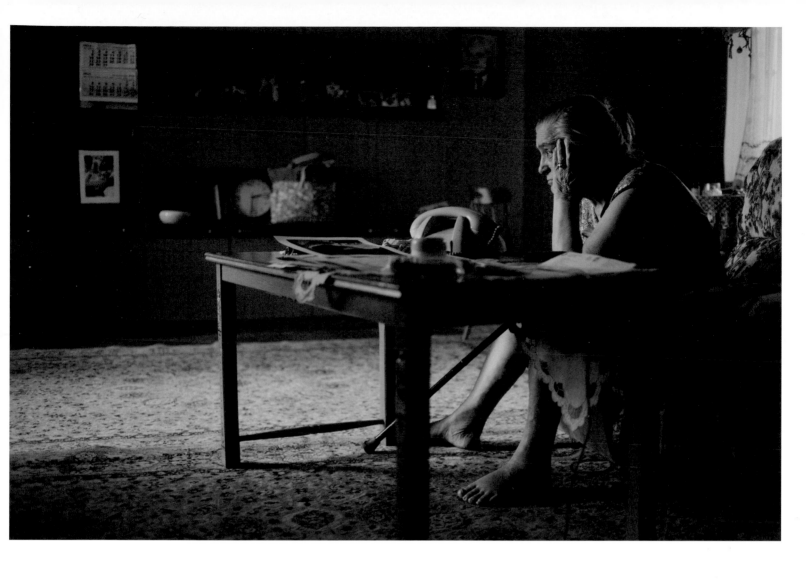

IVAN MASLAROV
THINKING ABOUT MY FATHER
JUNE 2013

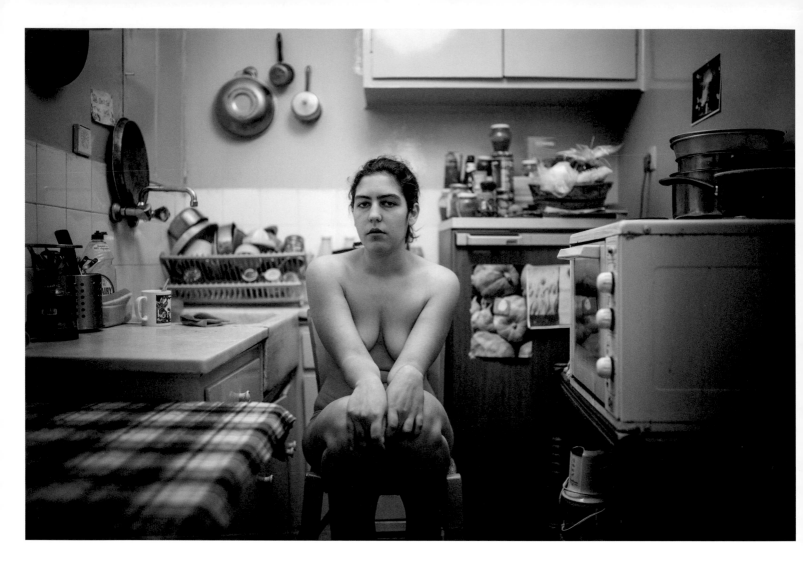

KONSTANTINOS KARTELIAS
NEPHELI
FROM THE SERIES *GREEKS UNDER THE ECONOMIC CRISIS*
APRIL 2014

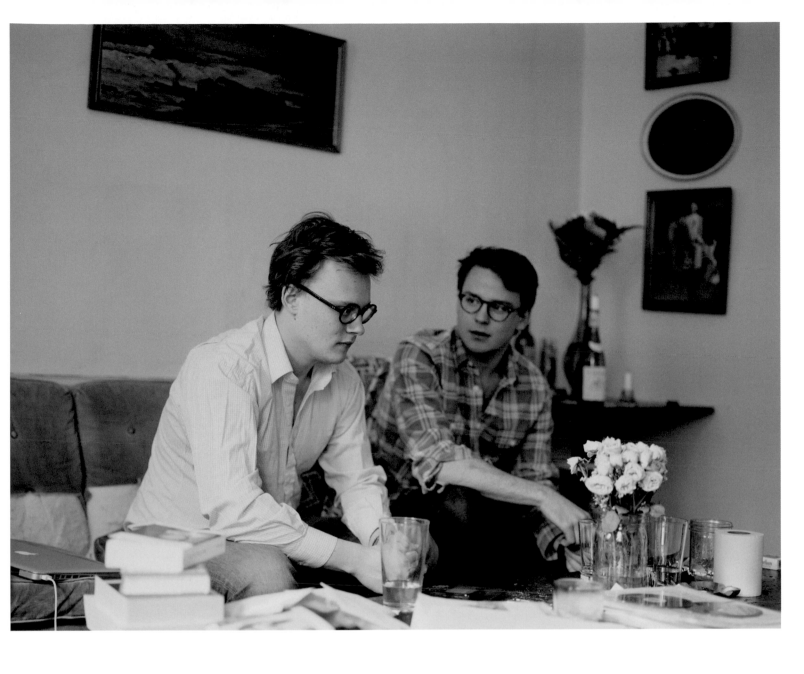

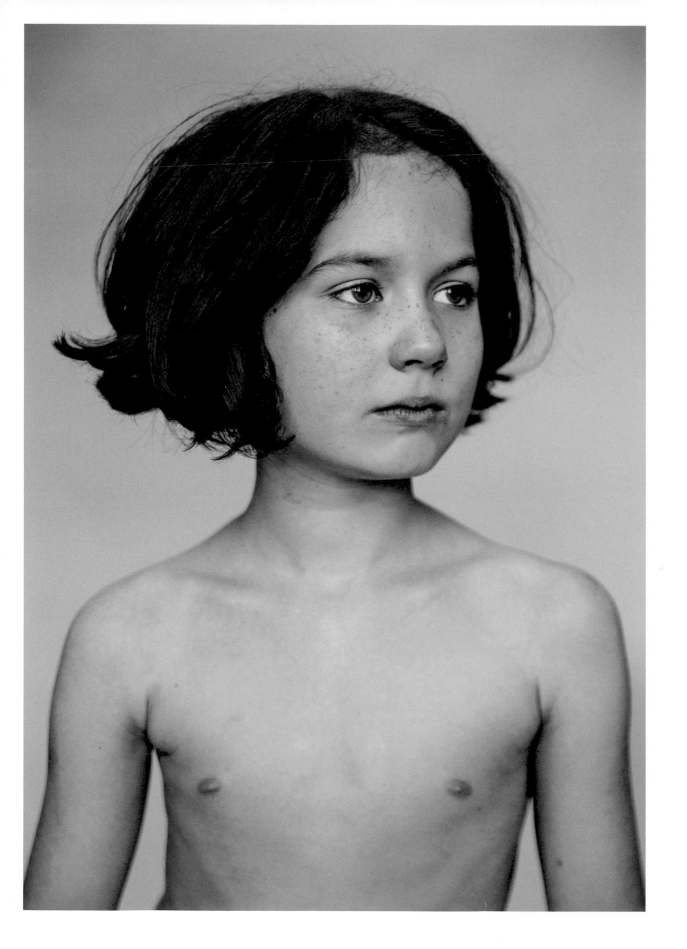

LENKA RAYN H.
UNEXPECTED
DECEMBER 2013

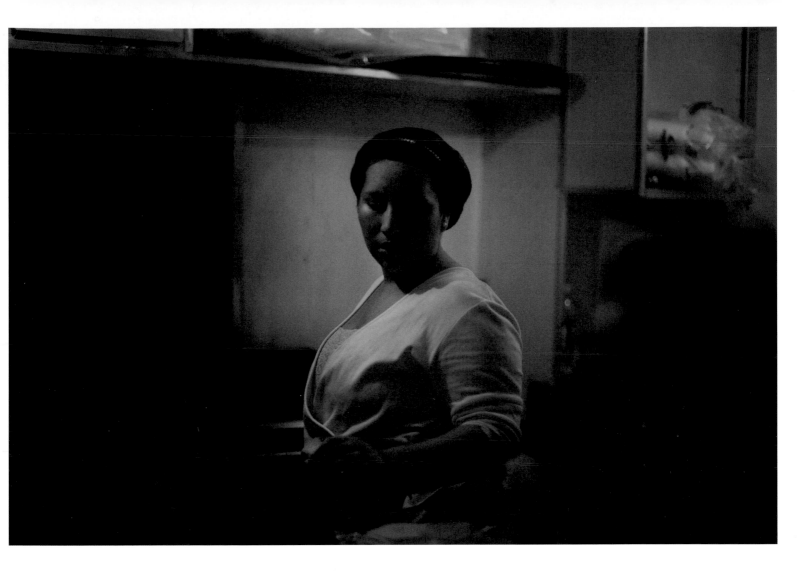

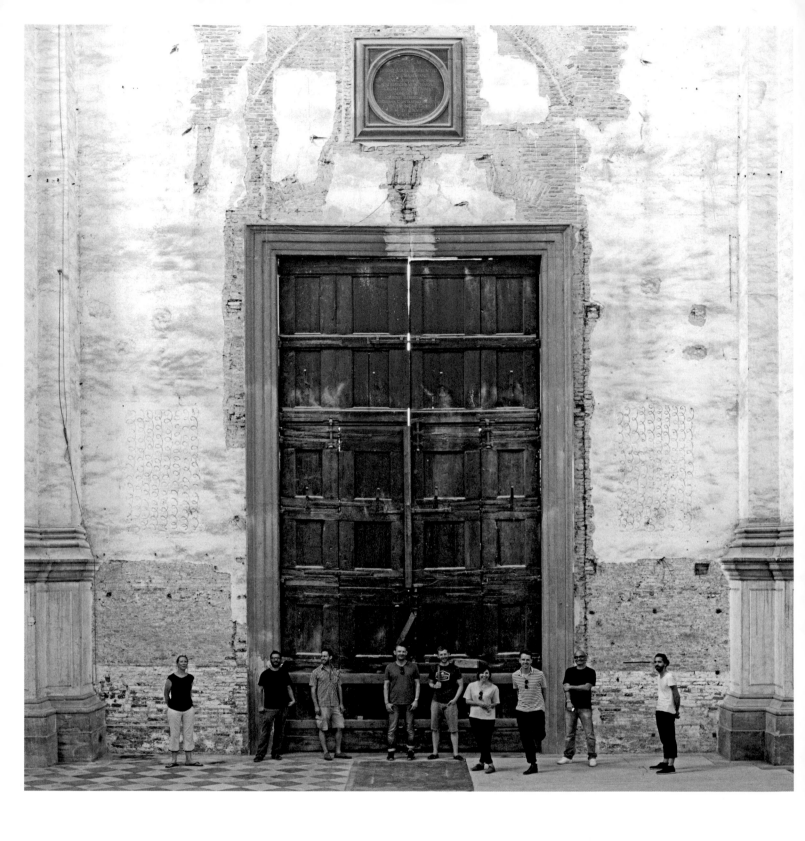

VALERIE BENNETT
ROZ BARR ARCHITECTS IN THE CHURCH OF SAN LORENZO, VENICE
FROM THE SERIES *ARCHITECTS*
JUNE 2014

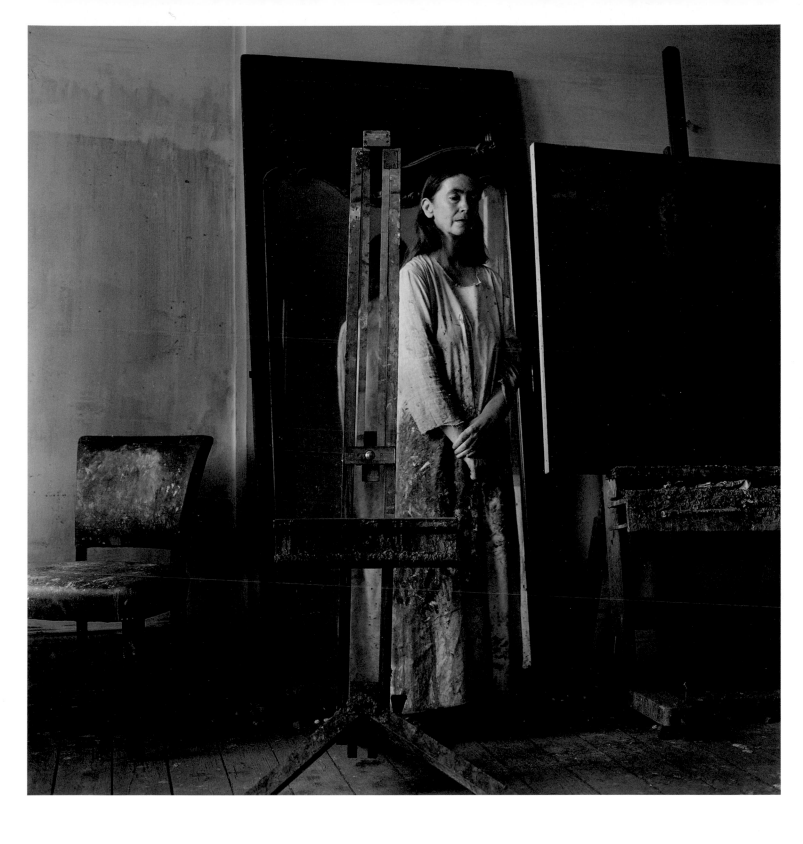

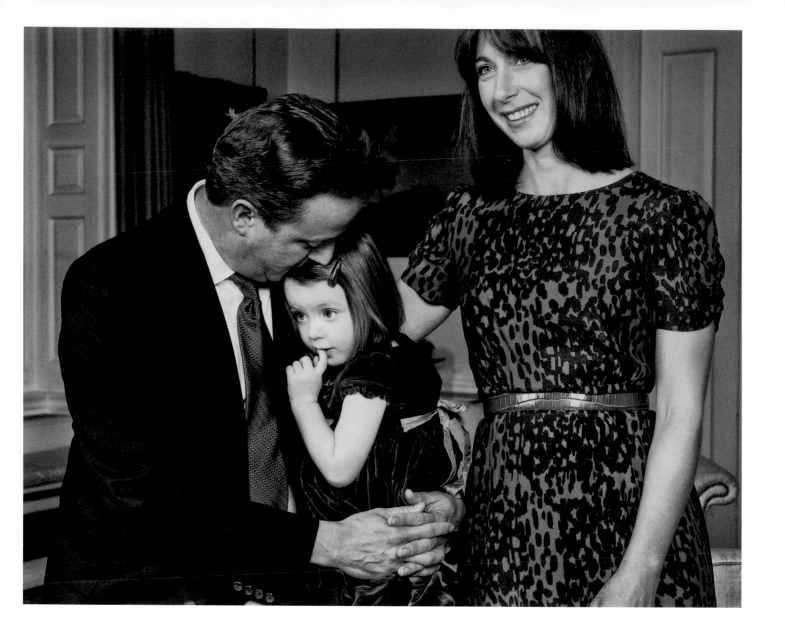

TOM STODDART
PRIME MINISTER DAVID CAMERON WITH WIFE SAMANTHA
AND DAUGHTER FLORENCE
OCTOBER 2013

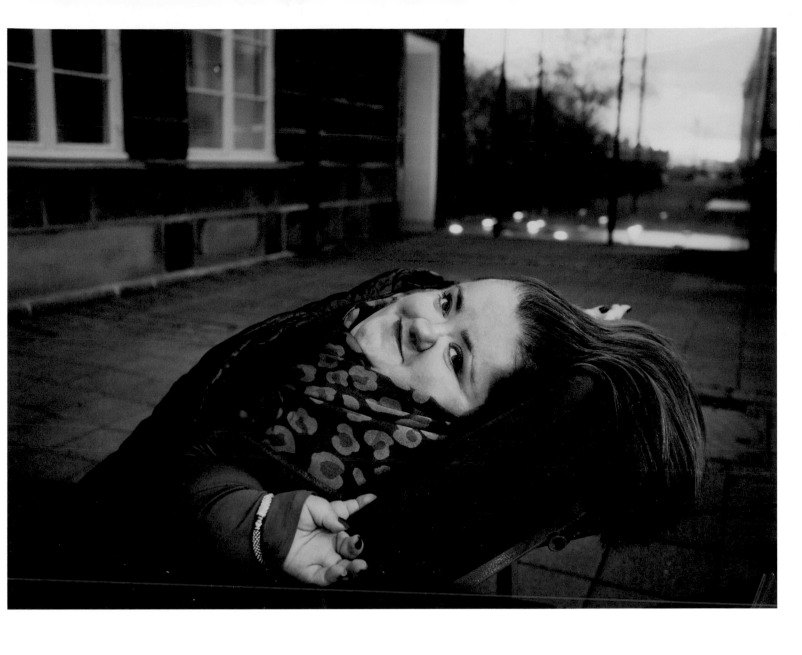

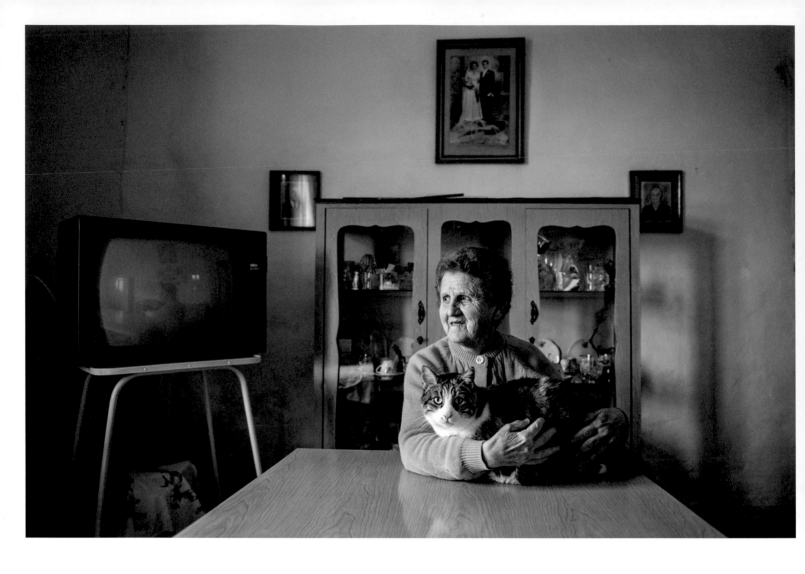

JOSEPH SMITH
COMPANIONS
FROM THE SERIES *SURVIVORS – THE AGEING POPULATION OF BIRGU*
MARCH 2014

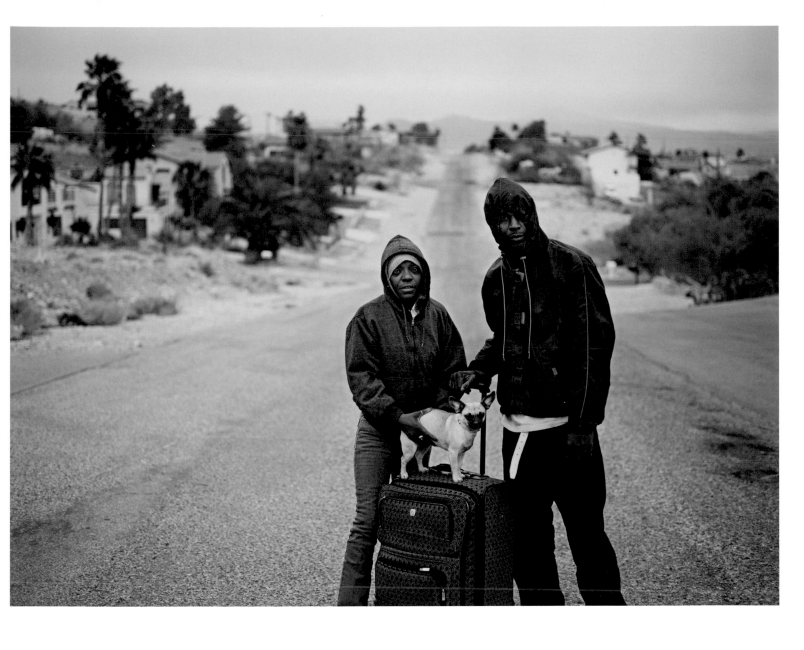

DAVID HARRIMAN
TRUTH, FAITH & KITTY
FROM THE SERIES *THE MEADOW'S EDGE*
FEBRUARY 2014

ZED NELSON
'M', 'P' & 'JJ'
FROM THE SERIES *HACKNEY – A TALE OF TWO CITIES*
APRIL 2013

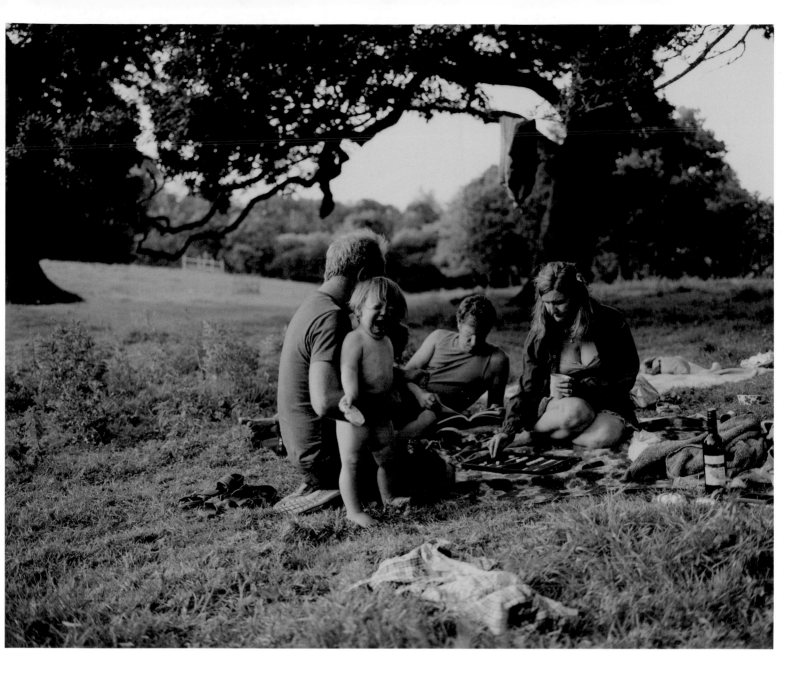

SIAN DAVEY
UNTITLED
FROM THE SERIES *THE RIVER*
AUGUST 2013

LIST OF EXHIBITORS

Michele Aboud **54**
Sara Al Obaidly **52**
Ian Atkinson **26**

Catherine Balet **44**
Valerie Bennett **72**
Hayley Benoit **53**

Shelley Calton **33**
Jon Cartwright **43**
Laurence Cartwright **35**
Micaela Cianci **29**

Sian Davey **79**

Chris Frazer Smith **34**
Jessica Fulford-Dobson **16**

Offer Goldfarb **36**
Tomasz Gudzowaty **60**

David Harriman **77**
Victoria Hely-Hutchinson **69**
Tracy Howl **32**
Tobias Hutzler **59**

Tom Jamieson **58**

Konstantinos Kartelias **68**
Buki Koshoni **62**
Karan Kumar Sachdev **50**

Sarah Lee **41**

Ivan Maslarov **67**
Chloé Meunier **65**
Marcia Michael **56**
Margaret Mitchell **61**
Gabrielle Motola **75**
Kelvin Murray **47**

Zed Nelson **78**
Nepomuk **64**

Laura Pannack **22**
Sami Parkkinen **38**
Viviana Peretti **27**
Zoe Perry-Wood **28**
Giles Price **42**
Birgit Püve **18**

Blerim Racaj **20**
Neil Raja **51**
Lenka Rayn H. **70**
Mark Read **55**
Richard Renaldi **31**
Graeme Robertson **57**

Gorm Shackelford **49**
Nicholas Sinclair **73**
Joseph Smith **76**
Laura Stevens **66**
Ben Stockley **71**
Tom Stoddart **74**
Paul Stuart **45**
Justin Sutcliffe **46**

Heiko Tiemann **37**
Robert Timothy **30**
David Titlow **14**
Jon Tonks **25**

Bert Verwelius **40**
Elaine Vizor, MA **48**

Ann-Christine Woehrl **63**
Jill Wooster **39**